THE ART OF ROCKSTEADY'S BATMAN™

THE ART OF
ROCKSTEADY'S
BATMAN™

ARKHAM **ASYLUM** / ARKHAM **CITY** / ARKHAM **KNIGHT**

TEXT BY DANIEL WALLACE

ABRAMS / NEW YORK

BATMAN HAS REMAINED POPULAR THROUGHOUT WILDLY DIFFERING ERAS OF POP CULTURE. HE HAS STARRED IN COMICS, ANIMATION, AND BILLION-DOLLAR MOVIE BLOCKBUSTERS.

THE ARKHAM TRILOGY—ENCOMPASSING 2009'S BATMAN: ARKHAM ASYLUM, 2011'S BATMAN: ARKHAM CITY, AND 2015'S BATMAN: ARKHAM KNIGHT—SHOWED THE WORLD A NEW BATMAN, AND IN THE PROCESS IT ALLOWED BATMAN FANS TO EXPLORE AN ENTIRELY NEW UNIVERSE. THE ARKHAM TRILOGY PROVED THAT SUPER HERO GAMES COULD BE BOTH EMOTIONALLY ENGAGING AND ARTISTICALLY STUNNING.

THIS MASTERFUL MIX OF ART DIRECTION, STORYTELLING, AND GAMEPLAY SET A NEW STANDARD, ONE ON FULL DISPLAY IN THESE PAGES. STEP INSIDE ARKHAM AND LEARN HOW THE DEVELOPERS, ARTISTS, WRITERS, AND PROGRAMMERS REIMAGINED THE DARK KNIGHT AND HOOKED A WHOLE NEW GENERATION OF FANS.

PAGE 004 An early "mood piece" by John Gravato, created to help the art department determine where they might go with Batman's design.

ABOVE An early concept for the asylum manor, featuring Gothic elements and architectural experimentation.

PART //1
ENTERING ARKHAM

ROCKSTEADY STUDIOS, A SMALL DEVELOPER WITH A STAFF OF 40 AS OF EARLY 2007, DIDN'T HAVE AN EXTENSIVE TRACK RECORD.

"
WE WERE DRIVEN BY A COMBINATION OF PASSION, HUNGER, AND A SORT OF NAÏVETÉ ABOUT ALL THE POSSIBILITIES IN FRONT OF US.
"

What they did have was plenty of passion. Founded in December 2004, Rocksteady had released a single game—*Urban Chaos: Riot Response*—to favorable reviews.

Publisher Eidos Interactive had the rights to make a Batman game, and Eidos approached Rocksteady to see what the studio could do. Game director Sefton Hill and his team quickly switched their brains into Gotham City mode.

"The immediate reaction when we got the news that we had an opportunity to work on a Batman game was pure excitement," says Hill. "Creating a game based on a world and characters that we loved was a huge privilege. There was no expectation that this was going to achieve a huge level of success. We were driven by a combination of passion, hunger, and a sort of naïveté about all the possibilities in front of us."

In thinking about what kind of game they wanted to make, Hill's team members built their initial pitch around four pillars that involved both story and gameplay.

"The first pillar was how Batman would navigate in the world," says Hill. "Second was the 'world's greatest detective' aspect of Batman's character, which was something we felt hadn't really been explored. Third was the combat—I'm a big mar-tial arts fan, and we felt there was a gap there to create something rhythmic and beautiful that felt like a choreographed fight.

"The last of the four components was 'Batman as alpha predator.' The idea was that Batman would be able to stalk his prey—to take down armed thugs by being smarter and more prepared than they were.

"When we prepared that initial pitch, we didn't have all of the mechanics planned out, but we knew the emotion that we wanted the player to feel as they played. When the player picks up the pad and starts playing, they need to immediately feel like Batman—to feel that empowerment, of how awesome it is to be the Dark Knight."

By May 2007 Rocksteady started in on the game's story, and full production began in September. The following summer Rocksteady announced *Batman: Arkham Asylum* would appear as a 2009 release.

It wouldn't be long before anyone could check into the asylum.

PART // 2
ARKHAM ASYLUM

ARKHAM ASYLUM WASN'T JUST A GAME. IT WAS AN IMMERSIVE NARRATIVE THAT OFFERED A NEW CHAPTER IN THE BATMAN CANON.

"FROM THE BEGINNING, WE WANTED TO CREATE THE MOST DISTILLED BATMAN EXPERIENCE POSSIBLE."

And, in contrast to many of the Dark Knight's prior outings, this adventure would allow the audience to assume the identity of the protagonist.

If the players weren't hooked by the events unfolding around them, nothing else would work. Before Rocksteady programmed a single pixel, director Sefton Hill and writer Paul Crocker had to figure out what *Arkham Asylum* wanted to say.

"From the beginning, we wanted to create the most distilled Batman experience possible," says Crocker. "We knew the story and setting for the game needed to be focused and iconic, and that led us to the asylum."

Hill points out that Arkham offered the perfect space for setting Batman against his archenemy and for seeing the aftereffects of this clash of icons. "We wanted to tell a story between Batman and the Joker, and the confined environment was ideal for watching them bounce off each other," he says.

"But another reason was that we wanted to prove ourselves. Our vision demanded a very high attention to detail, to make it feel like every square inch of the environment reflected the presence of the characters and the history of the world. Batman's universe is so rich that we didn't want to create anything generic—and trying to create all of Gotham City wasn't something we were necessarily ready to do at that point—so we created a confined environment to keep that richness of texture."

In Rocksteady's reimagining, Arkham Asylum became a vast estate on an island connected by a bridge to mainland Gotham City. Hill also pushed to have players join the story *in medias res*.

"We weren't interested in exploring Batman's origins," he says. "The thing that excited us was to jump in with Batman and the Joker already established, which is one of the best things

about working with a cultural icon. Everyone has a basic idea of what Batman stands for and his relationships with key characters. We could throw the rulebook out the window and start telling our story from the middle, establishing the Batman power fantasy right from the start."

Joining Hill and Crocker on the writing team was a notable name from Batman popular culture. Paul Dini, co-creator of the 1990s Emmy Award–winning *Batman: The Animated Series* had ideas for the story that meshed neatly with Rocksteady's own goals.

"We decided early on that we wanted to collaborate with an established Batman writer," says Hill, "and Paul Dini's name was one of the first to come up. Working with Paul felt like a perfect way of staying grounded in the source material. On the animated series, Paul kept the core appeal of the Batman comics and brought it to a different medium without losing that magic. Because our aim was to take the appeal of Batman and bring it into a game, working with Paul felt like the ideal match."

After Dini signed on, the team fell into a fruitful collaboration. "We brainstormed how we wanted the story to go, and how to explore ways to have the characters interact," says Hill. "We talked at key project milestones to share our vision and to draw on Paul's encyclopedic knowledge of the characters to make sure that authenticity was still there.

"We wanted our game to be fun and engaging to play, but also totally familiar for Batman fans. We wanted everything to feel like it could only come from a Batman game, and working with Paul was a great start. It needed to be a uniquely Batman experience all over."

PREVIOUS SPREAD An exploration by John Gravato for the asylum's exterior. The mist and the tombstones give it a haunted atmosphere.

OPPOSITE The maximum-security section of the asylum, as depicted by John Gravato. The angular and crude concrete blocks were intended to provide architectural contrast with the rest of the asylum.

FOLLOWING SPREAD An architectural concept by Drew Wilson. The Gothic architecture in this piece is more rounded than the style used in the final game.

RIGHT This painted wall takes shape during the course of the game and provides visual reinforcement of the Joker's increasing control over the asylum.

OPPOSITE A marketing research concept based on a 3-D render from the game engine. Batman's silhouette is superimposed over the Joker's eye.

But a Batman game—like any game—needs to serve two masters: the gamer and the experiencer. The former dives deeply into native elements such as gameplay and combat systems. The latter is hooked by immersive settings and gripping story beats.

And of course, every player is a little of both. That realization drove Hill to avoid making checklists of boxes that needed to be ticked to keep both camps satisfied. In his view, *Arkham Asylum*'s status as a video game offered an expanded palette and an entirely new set of tools.

"There's a general saying in films that goes, 'don't tell, show,' but in games I believe it is, 'don't show, play,'" says Hill. "If you let the player interact with the story, they can be much more involved than if you just *show* them the story.

"I think we all want to play the events that shape the world and not just let them be something we watch. It has a big effect on the way we approach cinematics, because it means that

cutscenes are only used to convey things that the player doesn't do. There's very little action in the cinematics because we want to show the interaction between the characters."

Arkham Asylum would be told from a third-person perspective, focusing both on combat and stealth but emphasizing puzzle-solving that befits Batman's status as the world's greatest detective. Because Batman—orphaned by a criminal's gun—refused to ever take a life, the story and gameplay would also need to honor this vow while still maximizing player freedom.

Setting the game inside the corridors of Gotham City's infamous Arkham Asylum allowed every Bat-foe to join the party. Hill and his team set out to portray a madhouse that had been built by a madman: Amadeus Arkham.

"The Joker was our first choice as ringmaster, but the beauty of the asylum was that we could include any villain," says Crocker. "Scarecrow added an element of mental frailty to the game. I

STEAM HISSING OUT OF VENTS — FLAPPING CLOTH

RIB LIKE PIPES

BENT ARMS.

ONE EYE SMALLER

SIDE VIEW

FRONT

PREVIOUS SPREAD John Gravato's striking concept of the Joker, exploring the balance between comic book design and realism.

OPPOSITE A drawing in blue pencil by Drew Wilson, representing the Joker's supremacy over his nemesis.

ABOVE An early concept of a calling card to be used by Scarecrow. It was not used in the final game.

FOLLOWING SPREAD A marketing concept produced using in-game assets and portraying the duality between the Joker and Batman.

remember seeing a version of the first Scarecrow area and marveling as bricks and props were torn apart to symbolize the effect of Scarecrow tearing apart Bruce's mind.

"The Riddler was added to challenge the one aspect of Batman we hadn't yet tackled—his intellect. My favorite part is the way that if you fail to complete his challenges he descends into mocking your intelligence and giving more and more clues. It helped us define our Riddler as the person who was desperate to be Batman's intellectual superior, whilst also making players feel like they could outsmart him."

Interview tapes encountered during gameplay provide an optional—and extremely detailed—backstory for the inmates and the history of the asylum itself. "The tapes allowed us to dive

deep into the villains' individual psyches," says Crocker. "We could explore them in a way that tied them into the wider story while telling more personal stories that explained their conflict with Batman."

But *Arkham Asylum* wouldn't merely be a "greatest hits" of Batman foes. The Dark Knight's journey would culminate in a showdown with the Joker: his archenemy and his ideological opposite.

"We wanted to explore the relationship between Batman and the Joker, which is at the heart of some of the best Batman stories," says Hill. "I think that's one of the most interesting themes to explore—how Batman and the Joker are connected and aligned, just as much as they are conflicted against each other."

WE'RE ALL MAD HERE

A GREAT GAME BEGINS WITH A GRAND VISION.
FOR **ART DIRECTOR DAVID HEGO,**

Arkham Asylum needed to fuse two completely dissimilar styles: comic books and true-to-life realism.

"When starting a new game, the first task in art direction is to create a pitch that will sell the high-level ideas to the team in as few words as possible," he says. "The message needs to be as clear as possible. This is where the idea of clashing two diametrically opposed concepts—stylization and hyperrealism—came together.

"The hyperrealism part grew naturally. At Rocksteady, we have always been keen to push the quality and realism in our games through environments and character design. New visual technologies—shaders and lighting, physically based rendering—allowed us to explore this venue and push it as far as possible."

Yet the improved graphical tools wouldn't achieve the desired effect if the team didn't add a generous dose of imaginative exaggeration. "The stylization aspect came from our approach to the medium, based on the comics, to create our own version of the Batman universe," says Hego.

"We didn't stick with a particular representation or style. But we had the freedom to rethink and reinvent Gotham City's world. We would call it the Arkhamverse."

PREVIOUS SPREAD A cinematic shot from the beginning of *Arkham Asylum*, where Batman brings the Joker to the asylum and inadvertently sets off a larger plot.

OPPOSITE A conceptual illustration for a marketing piece by John Gravato, featuring a more stylized Joker than the one included in the final game.

LEFT John Gravato's pencil sketch of an early Batman character design.

HEROES AND ROGUES

THE GAME'S "ARKHAMVERSE" AESTHETIC MADE
ITS BIGGEST SPLASH IN THE CHARACTER DESIGN STAGE.

OPPOSITE The final in-game 3-D render for Killer Croc.

BELOW A character study for the Joker by Carlos D'Anda, injecting a degree of comic book stylization.

"The stylization in the characters was pretty straightforward," says Hego. "Batman's villains have a tendency to be quite theatrical, with strong traits and characteristics. But steering the design to a somewhat believable level is as important as the design itself.

"Realism and believability are two elements we stay as close to as possible while treating fantastic and extravagant ideas through stylization. The goal is to create a believable game world, but at the same time to introduce a ten-foot-tall crocodile mutant covered with realistic scales and pulling huge chains, who still shows a somewhat human side. While fantastical, it stays believable and realistic in the Arkhamverse."

Within the asylum's graffiti-scribbled walls, Batman comes across as a serious, sober out-

sider. The team quickly discovered that Batman couldn't look as over-the-top as his foes.

"When we started, we decided to push the boat right out there and make a crazy Gothic version of Batman—tall, thin, and very stylized," says lead character artist Andrew Coombes. "However, we quickly came to the realization that we had taken him too far—and in the process, lost something of the magic of his design. So we went back to some of the iconic Batman designs, from the likes of Alex Ross and Jim Lee."

ABOVE *Arkham Asylum*'s in-game 3-D render of the Joker.

BELOW A John Gravato concept of a distorted Joker following his physical transformation via the Titan formula.

OPPOSITE, TOP The Joker's poison-dart gun. Art by Lee Oliver.

OPPOSITE, BOTTOM An oversize pistol to be used by the Joker. Art by Lee Oliver.

The Joker proved just as vital a design challenge as Batman. "I love the dynamic between Batman and the Joker," says Sefton Hill. "That love/hate relationship, and the fact that they both help define each other's existence. It's a fascinating aspect of the Batman mythos."

Comic book artist Jim Lee had a direct hand in the character design process through the involvement of his art studio, WildStorm Productions. A team of artists at WildStorm, including Carlos D'Anda, worked in conjunction with the illustrators at Rocksteady to refine the look of Batman and other characters.

"I was at WildStorm doing concept work and art direction for *DC Universe Online*, so I was already in that head space," recalls D'Anda. "One day Jim asked me if I wanted to do some designs for a new Batman game. Mind you, at the time, Batman games had been known for being kind of forgettable, so there were no expectations whatsoever—which actually worked in our favor.

"At the time, nobody knew what this was about to become. I spoke to Sefton Hill, Paul Dini, and David Hego about the script and how they envisioned the game. It almost felt like an indie game, because the interactions were within a pretty small group. The whole process was very relaxed and flexible."

D'Anda helped define the game's interpretation of Batman. Once the early Gothic experimentation had been discarded, Batman gained a more grounded stance with realistic musculature,

wearing a black-and-gray costume reminiscent of military body armor.

The patients encountered by players inside the asylum would draw heavily from the familiar ranks of Batman's Rogues Gallery. But due to their status as inmates, most of these villains could not possibly wear their classic costumes. The possibility of prison uniforms became just one element in a broader opportunity to redesign the rogues, one foe at a time.

"We wanted people to instantly recognize these much-loved characters, but also wanted to bring something new and exciting to them and make *Arkham Asylum* its own unique flavor of Batman," says Coombes, who points to the Joker's sidekick Harley Quinn as an example. In this game, Harley would jettison her jester outfit from *Batman: The Animated Series* and join the Arkhamverse.

"Our take on Harley is worlds apart from the red-and-black checkered bodysuit worn by the Harley of old, yet she is still easily recognizable as Harley," explains Coombes. "Her design retains that playful naughtiness that makes her such a great character."

David Hego points out the thoughtful, character-based details in Harley's costume that are easy to miss. "In *Arkham Asylum* Harley has only just fallen in love with the Joker," he says. "Through the design of her outfit you can see the remains of a nurse outfit, from her job in the asylum when she first met the Joker. But there's already a twist of jester in her design."

VENOM PUMPS FROM
HERE TO DARTS

SINGLE SHOT OF VENOM
IN CAPSULE

FILTERS THROUGH QUICK
WHEN INJECTED

JOKERS VENOM DART GUN

FILTERS THROUGH QUICK

Carlos D'Anda kept busy designing other inmates, including the nightmarish Scarecrow, the mutated reptile Killer Croc, and the steroid-infused grappler Bane.

"Scarecrow and Killer Croc were in my first batch," says D'Anda. "They went from rough to final with few changes. But Scarecrow and probably Bane were the ones that really allowed me to establish the aesthetic and flavor of the characters.

"Scarecrow and Bane and others were the characters we had the most free rein on, the ones dressed in elements from the prison. With characters like Batman and the Joker, we had to ride a fine line between their classic looks and something that would still feel like Arkham. It was a constant back and forth, a process of feeling out where to push and where to pull.

"I wanted everything to feel industrial. I kept thinking of Detroit muscle cars from the seventies. I wanted the design elements to feel mean and durable—nothing high-tech and fanciful, but practical and tough."

When it came to the game's Titan-infused monsters, stylization finally took the lead over realism. Andrew Coombes determined how to approach these fun-house mirror distortions. "The Titans are super-exaggerated beasts, so we wanted them to be extreme—but still grounded in reality," he says. "To find this balance, we built the model with exaggerated but recognizable human anatomy. We also packed realistic detail into the skin textures."

D'Anda tried his hand at designing a Titan-twisted Joker. "Rocksteady had already designed what the goons would look like after being infected with the Titan formula, so my Joker had to fit," he says. "I kept similar proportions, but I was thinking about the Joker's signature features."

The lineup of character designs created for *Arkham Asylum* established a baseline for an aesthetic that would populate an entire gaming trilogy. "We were given lots of room to play," reflects D'Anda. "They trusted us to do our thing. That allowed the game to stand on its own—apart from comics and movies—while still feeling true to the spirit of Batman.

"The whole experience was amazing, especially in hindsight. It's truly humbling to know I played a part in bringing the Arkhamverse to life."

Stolen Warden's glasses shirt and carnation.

Arkham guard's gun belt

OPPOSITE A final in-game 3-D render for Batman.

TOP One of many stone tablets encountered throughout the game environment. The art department used the beetle as a symbol of insanity, contrary to its meaning in Egyptian culture.

ABOVE Variations on an earlier John Gravato design for Harley, done in a more realistic style.

RIGHT Detailed sketches for Batman's gauntlets and boots by John Gravato.

FAR RIGHT A near-final John Gravato character design for Batman.

ABOVE A character concept by Carlos D'Anda for Harley Quinn, exploring a more stylized look.

OPPOSITE A final in-game 3-D render for Harley Quinn.

Prison blanket, torn and stiched

Medical syringes strapped to the fingers

OPPOSITE An early character concept for Scarecrow by John Gravato. The final design was more stylized than this realistic version.

ABOVE A Carlos D'Arda character concept for Scarecrow, intentionally stretching the boundaries of a com c-book style.

RIGHT Variations on John Gravato's character design for Bane.

FAR RIGHT Variations on a John Gravato character design for Killer Croc, featuring a more realistic human figure.

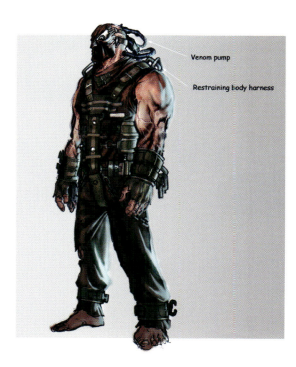

Venom pump

Restraining body harness

Chains pierced into the hide

Smooth underbelly similar to reptiles

Ridges on the hide that run along the spine and the outer edges of the arms

ABOVE A second character study by John Gravato. Killer
Croc's final design went in a more animalistic direction.

OPPOSITE An energetic character study for Killer Croc.
Art by John Gravato.

ABOVE An early John Gravato concept for Poison Ivy.

OPPOSITE An in-game rendering of Poison Ivy.

OPPOSITE A color concept of a Titan thug. The spine contains metallic elements inspired by body modification.

TOP In-game render of a Joker thug infected with the Titan formula (derived from the super-steroid called Venom).

ABOVE, LEFT Carlos D'Anda's version of the Joker in his final boss form, featuring bone spurs and hooked talons.

ABOVE, RIGHT An early sketch for the extreme body distortion caused by the game's Titan formula.

OPPOSITE A John Gravato concept for a Titan-infected Joker.

ABOVE A leaner Titan Joker appears in this John Gravato concept.

THIS SPREAD These John Gravato concepts explored what an average inmate at Arkham Asylum might look like. The team wanted to evoke the worst, most horrific treatments that might be inflicted upon unfortunate Arkham patients.

EXPLORING ARKHAM ASYLUM

IF BATMAN'S NEW GAME WAS GOING TO TAKE PLACE INSIDE AN ASYLUM, **THEN THE BUILDING HAD TO FEEL AS INSANE AS THE LUNATICS IT HOUSED.**

BEYOND THE VISUAL QUALITY AND THE AESTHETIC, WE WANT TO TELL STORIES.

OPPOSITE A painted concept of Arkham's exterior by Drew Wilson, incorporating a forest of pointed spires.

ABOVE A very early conceptual sketch by Drew Wilson, featuring a beetle motif on the asylum's entry gates.

David Hego's principle of stylized realism informed the architecture of the asylum and the design of its surrounding grounds—an environment envisioned as an Alcatraz-style island prison.

"Accentuating and exaggerating the shapes and volumes [of the environments] brings another layer of stylization," explains Hego. "The walls have to be unnaturally tall, stretching to the darkness of the rafters. The pipework should never go in a straight line but should always take the most convoluted route from one point to another. The trees should appear crooked and tortured. All of this while still treating bricks, rust, wetness, and dust as realistically as possible."

To portray the asylum, the art team lent the island an air of history. Each building wore a unique architectural style that spoke to the era in which it had been built.

"Deciding on an environmental visual scheme is not a simple task," says Hego. "On the one side you want to avoid creating another generic warehouse, or another abandoned factory—you've seen it a dozen times in the last ten years.

PREVIOUS SPREAD An in-game shot of Batman within the Arkham exterior environment.

LEFT A pencil study by Drew Wilson for the asylum's entrance, with the crumbling exterior meant to symbolize the onset of madness. The nameplate plaque was not used in the final game.

FOLLOWING SPREAD This concept by John Gravato showcases several key elements of Arkham architecture, including stretched windows, vertical pillars, and Victorian details.

"On the other side, you want to come up with interesting themes. The artists are going to spend at least two years of their lives working on the game, so you want them to be inspired and to stay fresh."

On a game like *Arkham Asylum*, art direction becomes another form of storytelling. "A notion we keep close to our hearts is creating meaningful environments—what we call visual narration," says Hego. "We want the place to feel like more than a movie set. We want to inject life, history, and details that the player will decipher while exploring.

"Beyond the visual quality and the aesthetic, we want to tell stories."

And like all stories, video games offer linear narratives in which the characters progress through a series of milestones. Visual design can reinforce this progression by providing the player with varied, sequential locales.

"When thinking about environments, we want to add as much variety as possible to reward the player—to make him feel that there is an evolution through his journey," says Hego. "In the same way that some video games let the player go through a jungle level, a desert level, and a lava level, we want to bring a sense of environmental evolution through the story."

The administrative area of Arkham, for example, feels as if it has been walled off for more than a century. "It's the oldest part of the asylum and still looks like it did when founded by Amadeus Arkham," says Hego. "The architecture of the admin building borrows from the purest Gothic revival style, with flamboyant elongated windows, tall stone pillars, and pointed arches."

Femme fatale Poison Ivy grows her own realm in the heart of the Arkham botanical gardens—a place of lush greenery and carnivorous flora. "The gardens demonstrate some of our architectural exploration," says Hego. "Moving forward from a Gothic influence, we added more Victorian flavors—with intricate metalwork and glasswork—and the curves get softer. The color palette pushes toward green tones to reinforce the sense of overgrowth and decay. We imagined the patients of the asylum coming for walks as part of their therapy to cure their diseased minds."

Batman never leaves Arkham's island in the game, but that didn't stop the team from including one of the most famous locations in Bat-lore. "It was not obvious at first to create a Batcave under the asylum, but the temptation was too strong for the first game of the series," says Hego. "It is such an iconic location of the Batman universe—even if this one is not the official Batcave, but a secret one that Batman keeps as an emergency lair.

Maybe we can try rectangle bars as main supports?

Reuse of the window arch shape.
Also re-use of Jamie's twirly detail,
we need to echo the interior of the structure as much as
possible for cohesion.

The same gargoyle that will be used throughout the
Arkham level.

jaggered rocks., their lines
pointing towards the house. This
will lead the veiwers eye to to the
gate and to the house behind.

Pipework main elements.

Light shape

"The platform leading to it is held on chains. The metal structures are attached to the rock faces, hanging above an infinite chasm and bathed by a very crude, blue light. Most of the equipment is covered by plastic sheets, adding to the mystery of the place."

Even though *Arkham Asylum*'s action doesn't extend beyond the island's borders, the team found ways to evoke a broader sense of scale. If the player gains a vantage point and directs the camera across the waters of the bay, the distant but welcoming lights of Gotham City come into view.

"While developing the island and its shores, we came across the task to design the 'out of gameplay' boundaries—the water surface, the lighthouse, and the buoys," says Hego. "A bit farther on the horizon we created Gotham City's backdrop. Back then, it only used a few dozen triangles. Seven years later [on *Arkham Knight*] we would create a new version, but this time with hundreds of millions of polygons."

But there is one avenue for leaving the island behind—an option that comes at the cost of Batman's sanity. At various points in the game, fear toxins released by Scarecrow trigger nightmarish visions that play upon the Dark Knight's worst fears.

"Scarecrow's hallucinations were a good exercise in destructuring an environment," says Hego. "The introduction to this part of the game is as plain and banal as possible—the player walks down a very ordinary corridor and through a morgue. Nothing prepares you for what's coming. It is very important to keep the world realistic and believable—the surprise to the player is then even more memorable when reality shatters and the world becomes completely abstract."

Designing artwork for a game often involves determining how to deliver wordless, visual information to the player. Environments can offer clues, not merely serve as moody backdrops. To achieve these effects, Hego's team employed the tools of light, shadow, coolness, and warmth.

"To help in navigation, and in the memorization of highlights in the environment, it is important to create peculiar elements that act as visual checkpoints," says Hego. "A room's characteristic element—such as a statue, or a door at the end of a corridor—can be a point of focus in a room and help the visual narration.

"But this is often not enough to make a point of focus stand out, especially with the amount of details spread in the environment. Granularity and attention to detail are the important points we keep consistent through the art, and sometimes we add 'noise.'

"Lighting is a great tool to differentiate to the player what's important and what's just set dressing. Two ways to bring these points of focus forward are contrast through brightness and darkness and contrast through the use of complementary colors. A lit door at the end of a dark corridor, or a junction box lit with a warm orange color in a cool blue environment, can highlight important elements in the environment and move the player forward.

"We also play with the player's expectations to create reveals—for example, we force ourselves to create a boring, dark corridor, and then reveal an amazing statue lit with warm lighting around the corner."

OPPOSITE Produced late in the development process, these images of crooked pipework and heavy metal doors became part of the "bible" for designing the interior architecture of the asylum.

ABOVE The art team designed this statue with modularity in mind. The wings and arms could be swapped out to easily create a variety of different statues.

ABOVE, RIGHT The scale of this door emphasizes the asylum's near-impossible qualities of verticality.

PIPES AND MACHINE PARTS
IN RECESS

MEDICAL AND CAVE WALLS

BANE & BATMAN SMASH THROUGH
WALL TO REVEAL ROOM

CENTRAL METAL MESH FLOORING WITH OUTER CONCRETE

ABOVE A sketch for the "boss environment" in which Batman faces off against Bane.

LEFT A blueprint concept for the asylum, intended to be encountered in-game.

OPPOSITE A very rough John Gravato concept for the botanical garden environment, experimenting with a sheer drop-off.

OPPOSITE, TOP Lee Oliver's take on the botanical garden interior, where Batman must confront a monstrously transformed Poison Ivy.

OPPOSITE, BOTTOM John Gravato's concept for the botanical garden environment.

ABOVE A Lee Oliver illustration of the asylum's medical wing.

RIGHT A John Gravato concept for one of Poison Ivy's killer plants, to be encountered throughout the game.

Proximity spores mines fired off and stick to surroundings.
or mouth opens as the entire plant is about to explode.

Mouth opens to reveal flesh-like tissue and jaggered rows of razor sharp teeth.

Venom oozes and perspires out of the plant.

Venom sacks heave, expand and bulge at the base of the organism

Clusters of seperate venom sacks populate the area around the base, blending the organism more visually into its surroundings and stop it from looking pasted on.

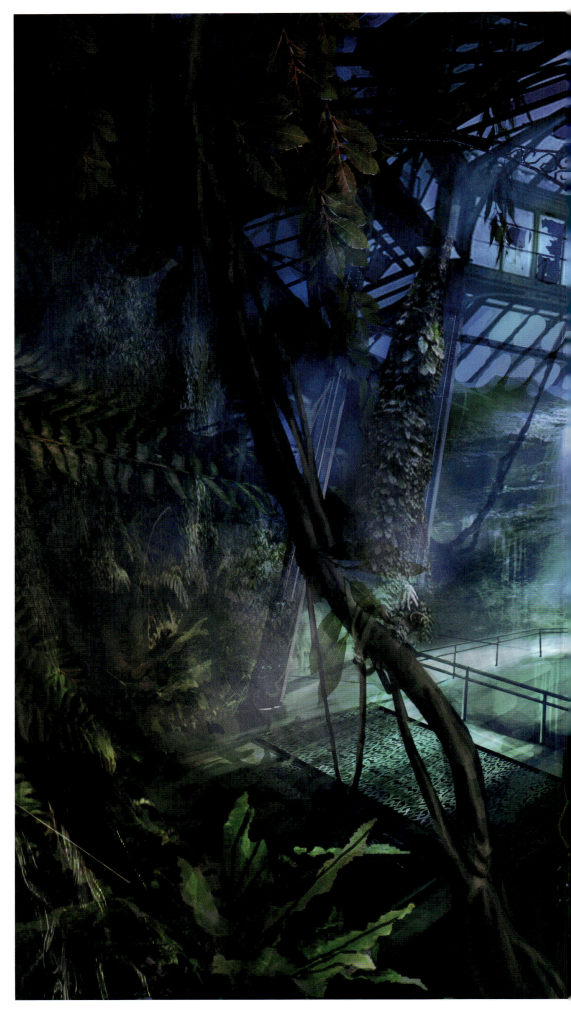

RIGHT This overgrown environment features massive clockwork cogs, a design element encountered frequently in the asylum to symbolize the loss of time. Art by John Gravato.

FOLLOWING SPREAD, LEFT Batman is dwarfed by the massive scale of the island's catacombs in this piece by John Gravato.

FOLLOWING SPREAD, RIGHT The disused backup Batcave located beneath the island is captured by John Gravato, contrasting the metal structures with the natural rock of the chasm.

ABOVE The endless walls of filing cabinets in this piece by John
Gravato emphasize the verticality of the Arkham environment.

ABOVE A clock-tower study by John Gravato. The scale of the mechanisms is intentionally exaggerated to emphasize the game's larger-than-life reality.

ABOVE Arkham Asylum's maximum-security area is seen in this John Gravato illustration.
The cells can be moved from one location to another using ceiling-mounted tracks.

FOUR BIG INDUSTRIAL STEAM PIPES CIRCLE THE ARENA BANE CHARGES
INTO THE PIPES BECOMING STUCK ALLOWING BATMAN TO ATTACK

SMASHED WALL WHERE BATMAN IS THROWN BY BANE FROM MEDICAL B6

TOP An early in-game screenshot with paintover elements, created to help conceptualize the battle arena in which Batman fights Bane.

ABOVE A Lee Oliver illustration depicting cells in the asylum's high-security wing.

TOP The Joker appears on a television set mounted on the head of a mannequin in this pencil study by Lee Oliver.

ABOVE A black-and-white study of Killer Croc's half-flooded subterranean lair.

CRUMBLING
STAIRS TO JETTY
FAR BELOW

GENERATOR
MECHANICS
LEAN-TO

PLUNGING DOWN TO WAVES

HIGH ACCESS

UNDER UP

MID
EMERGENCY
STAIRS

HIGH

HIGH
WINCH

MAIN
ENTRANCE

UNDER
UP

HIGH
ROCKS
OVER

VIEW
DOWN

CAVE ACCESS

TO CATACOMBS

THIS SPREAD An early concept depicting the island's lighthouse, originally intended to play a larger role in the game's narrative.

FOLLOWING SPREAD A John Gravato piece depicting the bridge that leads to the Arkham Island lighthouse, exploring a more metallic look.

STREWN
SUPPLIES
4 MAINTENANCE
EQUIPMENT.

BRIDGE LINK TO ARKHAM ISLAND

LIGHTHOUSE
GRAVATO

make this interior TALLER

ENHANCED LIGHT - CANNIBALIZED?
TO CREATE A BEAM WEAPON?

SPIRAL STAIRCASE. BROKEN

INTERTWINING POWER CABLES
- IMPROVISED POWER- MESSY
(BRAZIL STYLE)

PIPE ENTRIES from HIGH LINE.

EMERGENCY
STAIR
FUNCTIONAL &
RICKETY.

MAINTENANCE/
GENERATOR HUT
BEHIND

STAIRCASE
BROKEN

OPPOSITE The side view of the lighthouse environment. Believing that the game world was growing too large, the team made the decision to omit this element.

ABOVE The lighthouse is buffeted by waves in an early illustration by Drew Wilson.

RIGHT The distant skyline of Gotham City can be seen in this piece by Drew Wilson.

FOLLOWING SPREAD A stylized view of the asylum exterior by Drew Wilson. Developed as part of early research, this piece depicts the structures practically growing out of the rocks on the shoreline.

THIS PAGE A Lee Oliver study for the surrealistic Scarecrow environment, incorporating elements taken from the asylum's morgue.

OPPOSITE Another Lee Oliver take on the floating, frightening Scarecrow setting.

twisted ceiling frame with smashed glass

Catacomb bricks under concrete rendering

Brick work same as in Catacombs

Brick work decay where it meets rocks

Scarecrow Medical-S12-Detail (Morgue Wall)

OPPOSITE Scarecrow's nightmarish domain is captured in this color piece by Lee Oliver.

ABOVE John Gravato depicts Batman, dwarfed by massive clockwork cogs, making his way through the catacombs.

ABOVE Gears, valves, chains, and pipework meant to depict the ticking heart of the asylum dominate this illustration by John Gravato.

Pumproom

TOP Verticality and perspective are on display in this piece by John Gravato.

ABOVE This medical environment depicts where Bane is subjected to painful experiments to extract the Venom formula from his blood. Art by John Gravato.

ABOVE The asylum's morgue is seen in this piece by Lee Oliver. Scarecrow's fear gas is already beginning to creep in around the edges.

GEAR

BATMAN POSSESSES MANY SKILLS, BUT ARGUABLY
HIS MOST AMAZING ABILITY IS HIS SIMPLE READINESS.

" INSIDE THE ASYLUM, THE FULLY-EQUIPPED BATMAN PRACTICALLY SEEMS LIKE A VISITOR FROM ANOTHER PLANET. "

His utility belt is loaded with every gadget he could possibly need to get out of a tight scrape. *Arkham Asylum* allows players to use devices to progress through the levels, an aspect that Sefton Hill compares to the gameplay found in *Metroid* and *The Legend of Zelda*.

Inside the asylum, the fully equipped Batman practically seems like a visitor from another planet. His sleek, machined gear stands out sharply against Arkham's riotous surroundings.

"To increase the contrast between Batman's technology and the universe, we stepped the technological advancement of the world down," explains David Hego. "You'll notice that the equipment scattered around always feels retro. Computers have old keyboards and curved, fat CRT screens. The phones have an eighties feel. The environment is often covered with grime and dirt—it's a pretty grim world.

"Batman's gadgets come in two flavors," he continues. "The ones that are in Batman's possession or delivered to him during the adventure are designed with WayneTech in mind. They tend to be very functional, with a military and minimalistic aesthetic. Dark, brushed metal and high-tech materials. Holographic technology, designed to make sure that the information provided to the player would be readable on-screen. There was a bit of artistic license while still staying believable."

The second flavor is what happens when Batman's WayneTech gizmos get hybridized. "Batman can create or modify an existing gadget by retrofitting elements found in the environment, to give it an improved functionality," says Hego. "Electric wires and added modules create a custom feel to the device.

They highlight Batman's ability to create new gadgets when facing a problem."

One of Batman's most prominent gadgets is built directly into his cowl and is only experienced if the player enters a first-person scanning mode. This is "detective mode," an enhanced version of the environment reminiscent of the view from night-vision goggles and containing text boxes and glowing diagrams. The overuse of this eerie visual overlay had an adverse impact on *Arkham Asylum*'s art direction.

"From my point of view, detective mode created quite a few problems during development and after launch," admits Hego. "Detective mode needs to be powerful—Batman is the world's greatest detective, and he has access to the best technology available. Therefore the mode needs to reveal information unavailable to the common human. Batman can trace smoke particles and footprints, analyze the environment for weak structures, and even monitor people's levels of stress.

"The idea was to create a tinted and enhanced version of the world with color correction and augmented-reality elements superimposed to Batman's view. It worked pretty well—up to the point that some players played the entire game with detective mode on.

"Of course, this was not the effect we wanted. It was a bit shocking, like someone going to watch a movie at the cinema with orange-tinted sunglasses!"

OPPOSITE An in-game render of the Dark Knight's famed Batarang.

FOLLOWING SPREAD An in-game rendering of Batman in action, armed with his signature crime-fighting gear.

PROGRAMMING ARKHAM ASYLUM

ANY ARTWORK DEVELOPED FOR THE PRODUCTION OF A VIDEO GAME WON'T STAY IN STILL-IMAGE FOR LONG.

Bringing everything to life is the responsibility of the programmers, who build interactive environments, animate characters, generate in-game physics, and develop naturalistic combat systems.

Level designers at Rocksteady crafted simple environmental layouts of the worlds sketched out by the concept artists, laying down game-mechanic elements as volumes and shapes in preparation for the design work to follow. Working with those shells, environment artists dressed them up to suit art director David Hego's vision of the asylum. *Arkham Asylum* featured forty rooms connected by thirty-four corridors, plus three exterior zones and another three environments accessible via Scarecrow's hallucinations.

Rocksteady developed *Arkham Asylum* using a custom version of Epic Games' Unreal Engine 3. The process took more than a year, as the team worked out various prototypes and discovered how to get the best possible performance out of the tools.

"On previous games, we had developed our own custom state-based animation system," says Rocksteady's lead AI programmer, Tim Hanagan. "It allowed programmers to quickly and smoothly transition AI characters between different poses and integrate these animations into gameplay. When we moved over to the Unreal Engine, we ported over our existing system and took the opportunity to make some improvements. This included the addition of a visual animation state editor, fully integrated into the Unreal Editor."

What did that mean for the team's ability to craft convincing animations? Lead animator Zafer Coban's answer is simple: "There are no shortcuts."

The team's devotion to the highest standard of excellence found its true test in Batman—the only character taking center stage for hours and hours of gameplay. "We take great pride in every character that comes through our hands," says

Coban. "Each one is given the same attention to bring him or her to life in the best way we know. But of course, having the honor to bring life to a character such as Batman was a pleasure and a joy.

"I was a massive fan when I was a kid—bedsheets, posters on the walls, Batwing and Batmobile toys, and making sure I never missed an episode of the animated series. I never thought it would come to this, and I think most of us here at Rocksteady feel the same way."

Animating a character like Batman came with a host of pressures. As the story progressed and Batman took damage, the aftermath would be persistently visible upon the surface of his armor. Coban used more than seven hundred animations to perfect realistic movements for Batman's cape.

"Batman was the one character in our game who's on-screen basically one hundred percent of the time," he says. "We had a fairly humble animation team in terms of size, here at Rocksteady, but we needed to constantly evaluate everything we did to ensure we didn't sway off track from each other, and to stay true to the man we all know."

It's not enough to simulate everyday movements, not when Batman is anything but average. For Coban, everything came down to determining the actions that quintessentially convey the essence of the Dark Knight.

"People know Batman as the man standing above the streets on a gargoyle, looking down on the city with his cape billowing," he says. "Or cutting through the air, with the wind racing through his wings. Or domineering over every enemy and standing with no fear. We know these are the

TOP The early 3-D island model.

ABOVE A virtual model of Arkham Island created by Rocksteady's 3-D artists during the conceptual stage.

THIS PAGE 3-D models for the asylum's exterior buildings, created to test the practicality of various concepts.

Centre slit splits cape into two sections. Could help introduce a more interesting variation in the billowing cape physics.

things that define Batman. Our goals from the beginning of *Arkham Asylum* were to bring this iconic character to life, and to make the player feel like they were in control."

In many ways, it's identical to the role of an animator on a feature film—except for the fact that animating a character for a video game needs to account for the external factor of player control. It's an added layer of complexity, and one that Coban is prepared for.

"It's the fundamental part of our roles as animators, whether it be for films or games," says Coban. "Our job is to make the characters or creatures come to life so we can fully immerse the viewer. In our particular case [with gaming], animation plays a huge role in ensuring that the player is experiencing that world, or location, or realm, to its fullest."

The process is far more than programming; it requires the insight of an artist combined with the passion of a fan. "It starts by understanding the needs of the character," says Coban. "Who is he? What does he do? What has he done to get to this point? What is he feeling when he runs off and dives down the side of a building?

"We need to put ourselves into the minds of the characters so we can understand how they would move. And all of these are just stepping stones to moving us into actually animating the character. Without getting into the *skin* of the character, it's meaningless to try and animate them."

Live performances can be a first step in the animation process, and Rocksteady's motion-cap-

ture facility is a big asset for the developer. "Having a motion-capture studio on hand opens up an entirely new door when it comes to bringing these characters to life," says Coban. "I encourage the animators to get suited up and to act out the roles of the characters—or in some cases, the creatures—that they'll be animating. This way they have full control over these scenes, and in a sense they become puppet masters themselves. Being able to take what we've just captured and seeing it come to life in a character like Batman is a real joy."

Though it's important to keep the animation believable, it often makes sense to go beyond realism and emphasize a character's extreme abilities.

"You always have to see the results from a step back, so you can make a better judgment on what *looks* right versus what *is* right," says Coban. "On Batman, we have to keep a close eye on that realism. He is a man, after all, but a man that can do a little more than the usual.

"It has to be a good blend of realistic motion—conversation scenes, emotional set pieces, most of Batman's navigational movement set—seamlessly stitched with the more extreme content where we push the boundaries of real life to satisfy the cool factor. This could be things like how Batman glides through the air or how he navigates from one enemy in combat to another.

"All the time, we're toying with the boundaries of what's real. It ensures the player can relate to what he's seeing, but also ensures that he's experiencing what it would be like to be in the shoes of a true Super Hero."

ABOVE A John Gravato sketch exploring possible cape behaviors.

OPPOSITE In-game renders of Batman from various angles and stances.

1 : Launches off ledge

2: Tightened up posture equivalent to a olympic diver, he stays suspended in this pose for a second, even falls for a while before expanding his cape.

A complete confident leap. A master athlete with absolute precision and control

Flips cape to the rear as he lands, a more controlled landing.

Cape billows to the ground around him. Then he slowly rises to his feet.

Cape tips flap in the wind

Glider position 1

OPPOSITE Batman's movements are sketched out by John Gravato to assist with character animation.

ABOVE A John Gravato diagram capturing the chained-together moves of the Freeflow fighting system.

FOLLOWING SPREAD An in-game shot of Batman engaging in one-on-one combat.

BECOMING THE BATMAN

AS A VIDEO GAME—MORE IMPORTANTLY, AS A BATMAN VIDEO GAME—**ARKHAM ASYLUM COULDN'T AFFORD TO SKIMP ON THE COMBAT.**

In Batman lore, Bruce Wayne crisscrossed the globe to learn the secrets of hand-to-hand combat at the feet of the world's greatest martial arts masters, and at long range Batman rarely misses with a hurled Batarang. Yet he prefers to strike from cover, allowing his enemies to destroy themselves in their panic.

Arkham Asylum found a winning balance of combat and stealth that suited Batman's effortless approach. Rocksteady's Freeflow combat system allowed players to string together fluid takedowns without having to memorize button combos, while stealth aspects employed environmental design and enemy AI to their fullest.

"Using the Kismet visual scripting functionality provided by Unreal Engine, we built our own visual AI behavior system—perfectly suited to the way we wanted to mix designer-scripted behaviors and fully procedural, code-driven AI," says programmer Tim Hanagan. "This allowed designers to control any aspect of the AI during situations such as conversations or in-game cinematics while allowing us to create reactive and immersive gameplay systems such as Freeflow combat and stealth encounters."

Through stealth, Batman becomes the "bad guy for the bad guys." Each time he drops from a gargoyle and silently knocks out a thug, Batman raises the anxiety level of his remaining foes. When the player, as Batman, scouts the surroundings to determine the best way to pick off a pack of goons one by one, he becomes a predator hunting prey.

"Batman is all about psychological intimidation," says Hanagan. "Instilling fear in his enemies is one of the key ways he does this. We kept this in mind at all times while we were developing the stealth AI encounters. Being Batman should always feel empowering.

"Throughout early iterations of the stealth mechanic, we realized that being able to analyze the enemy and plan your actions made the player feel in control. We added the 'vantage point' mechanic, which allows you to survey the room to formulate a plan of attack, swing in to execute it, and quickly grapple away to safety.

"This really captures the feeling that Batman can appear from anywhere when you least expect it— especially when we focused on how the enemy thugs reacted to your actions. This is messaged to the player through their increasingly panicked dialogue and actions, and it culminates in them becoming terrified: jumping at imaginary sounds, shooting at shadows, and losing their ability to act rationally.

"Once the AI reaches this state, they're so scared that even the sight of Batman can leave them cowering on the floor. From that point on, they're easy pickings."

But sometimes Batman has to emerge from the shadows. *Arkham Asylum* hinged on combat, and lots of it. In many encounters, foes gang up on Batman in mobs of a dozen or more.

Freeflow, the combat mechanic used in *Arkham Asylum*, came about after the rejection of a long succession of concepts.

OPPOSITE Batman stands atop a gargoyle in this stylized piece by John Gravato.

ABOVE A rough sketch of
one of the asylum inmates, encountered
in the game as a low-level thug.

TOP Perched overhead, Batman
calmly observes his opponents in this
John Gravato illustration.

OPPOSITE This study by Drew Wilson
traces Batman's path across the rooftop.
The team rejected this type of linear
navigation very early in the process,
preferring open-ended exploration.

"The initial prototypes were based on trying to capture the rhythm and flow of combat using cinematic cameras and beat-matching mechanics," explains Hanagan. "The idea was to respond to enemy attacks by pressing the right button for the situation in time with the music. Successful moves would be rewarded with awesome animations showing off Batman's moves, which would lead directly into the next enemy attack. We created an early example of this using panels from Batman comics, which flashed on-screen to represent the player's and the enemy's moves.

"Most of us enjoyed this system, but it suffered from a lack of depth. It felt disconnected from the rest of the game, and the mechanics didn't fit well when applied to groups of enemies.

"We moved on to a simple, overhead 2-D prototype, focused more on crowd control and group combat. The player and the enemies were represented as on-screen circles, and you had three controls: a weak strike, a strong strike, and a redirect. Weak strikes briefly stunned enemies and knocked them away, strong strikes were used when you had space and could afford to concentrate on a single enemy, and redirects

sent an incoming thug off in any direction—stumbling thugs stunned other thugs.

"The stumbling block with this system was when we tried to move it into a fully animated 3-D world. It had a strong sense of rhythm, but trying to find the right animation style and linking it together into one flowing series of movements was tricky.

"The breakthrough came when Zafer Coban created a series of exaggerated, over-the-top strikes, in multiple directions at multiple ranges. By choosing the most appropriate move for the current strike—and by allowing you to chain these moves together at will—the bare bones of what would become Freeflow was born."

Hanagan also needed to develop animations for special combat moves. Freeflow rewarded combos, with an on-screen counter to keep track of successive hits on hapless thugs. "The rest of the project was spent on moves such as the cape stun and the combo takedown," he says. "Having a dedicated counter was one of the later additions, and the subject of much heated debate within the studio."

Straight Jacket Henchman

Lunatics

High Security Henchmen

THIS PAGE In-game renders of the henchmen and crazed inmates who populate the asylum.

1- Basic face paint, rough and thick.

2: Slightly more covered bottom half of the face along with gang ritualistic cuts made to mimic jokers grimace. However, these scars are an upside down smile to contrast the Jokers unique upright smile. Making them both unique and similar at the same time.

3: Scars mimic the jokers smile but only a minimal streak of paint to highlight them.

4: A material mask strapped on to partialy cover the face.

THIS PAGE Studies of face-painted henchmen working for the Joker.

ARKHAM ASYLUM: THE RECEPTION

AFTER TWENTY-ONE MONTHS OF WORK AND THE EXPANSION OF THE DEVELOPMENT TEAM **FROM FORTY MEMBERS TO SIXTY, ROCKSTEADY WAS READY TO INVITE PLAYERS INTO ARKHAM ASYLUM.**

" THE BEST SUPER HERO GAME, BAR NONE. "

OPPOSITE In-game render of the Batman model.

The game launched on August 25, 2009, in North America for PlayStation 3 and Xbox 360, followed by a European and Australian debut three days later. A PC release followed in September.

Critics were ecstatic—and the praise was something to shout about. Eurogamer labeled *Arkham Asylum* "the best Super Hero game, bar none," and the game received number-one and Game of the Year rankings in many outlets, including GamesRadar and the A.V. Club.

Critical validation felt nice, but the real proof of success fell to the players. There too, *Arkham Asylum* found itself smashing sales records. Gamers responded in droves, racking up 593,000 North American sales within the first five days. By the end of September, *Arkham Asylum* had moved more than 2.5 million units worldwide.

In a list of 2009 honors for achievements in gaming, the British Academy Video Games Awards gave *Arkham Asylum* the rankings of Best Game, Best Artistic Achievement, and Best Gameplay. At the 2009 Spike Video Game Awards, Rocksteady Studios won Studio of the Year.

Rocksteady released a Game of the Year edition in the spring of 2010, which included a clever antipiracy measure that disabled Batman's glid-

ing ability and left game thieves unable to make it past a poison-gas level. For mega-fans, the high-end Collector's Edition included a behind-the-scenes DVD, a leather-bound book detailing the crimes of Arkham's worst inmates, and a fourteen-inch replica Batarang.

"In retrospect we had a huge vision for *Arkham Asylum*, and the team did a fantastic job of realizing that vision," says Sefton Hill. "I'm immensely proud of the work that we did, and I know that we had a great team working extremely hard," says Hill. "I don't have any regrets about the final product or think there's anything that should've been included but wasn't."

Fans loved *Arkham Asylum*, but they wanted a sequel—and fast. What they didn't know was that Rocksteady had already planted the evidence. A secret room existed in *Arkham Asylum*, and Rocksteady waited for players to discover the Easter egg for themselves.

When no one did, Rocksteady spilled the beans. By blasting a hole in a destructible wall, players could explore Warden Quincy Sharp's secret office, where blueprints and pieces of concept art revealed the scope of the studio's ambition.

The next Arkham would not return to the asylum. Instead, the asylum would come to the city.

RIGHT An impressionistic piece by Kan Muftic depicting the guarded perimeter of the newly formed Arkham City.

PART //3
ARKHAM CITY

ESCAPING THE MADHOUSE?
NOT IF THIS TEAM HAD ANYTHING TO SAY ABOUT IT.

Arkham City painted the entire expanse of Gotham City with the brush of insanity, introducing a walled-off, apocalyptic metropolis whose streets were haunted by the asylum's worst inmates.

"Development on *Arkham City* only began once *Asylum* was finished,' says director Sefton Hill. "As a studio, our focus is on one project at a time to avoid spreading ourselves too thin, and to keep that laser-like focus on making each game the best it can possibly be."

The sequel-teasing Easter egg built into *Arkham Asylum*? According to Hill, it was more of a wish list than a sneak peek. "We had ideas bouncing around for something we'd do for a sequel. But

even very late in development on *Arkham Asylum* we still didn't know that we'd get the opportunity to make that sequel. We didn't know that the game would be as successful as it was.

"That's how the secret room came about. It was a simple case of us being hopeful that we'd get the opportunity to carry on with this awesome character.

"Fortunately—and fantastically—we did."

OPPOSITE Marketing compositions for *Arkham City* all shared the same high-contrast, washed-out look, unlike typical Batman imagery. Red was the only color in these illustrations, seen here in the Hugo Strange propaganda posters.

RIGHT Kan Muftic created this piece early in the design process while researching buildings and architectural forms.

FAR RIGHT Batman is perched above two guards in this piece by Kan Muftic, inspired by elements from Victorian London.

NO. K-37

C/O. O

ARKHAM
ASYLUM

STEEL
PLANT

ARKHAM

17/56-119/B

QUINCY SHAF

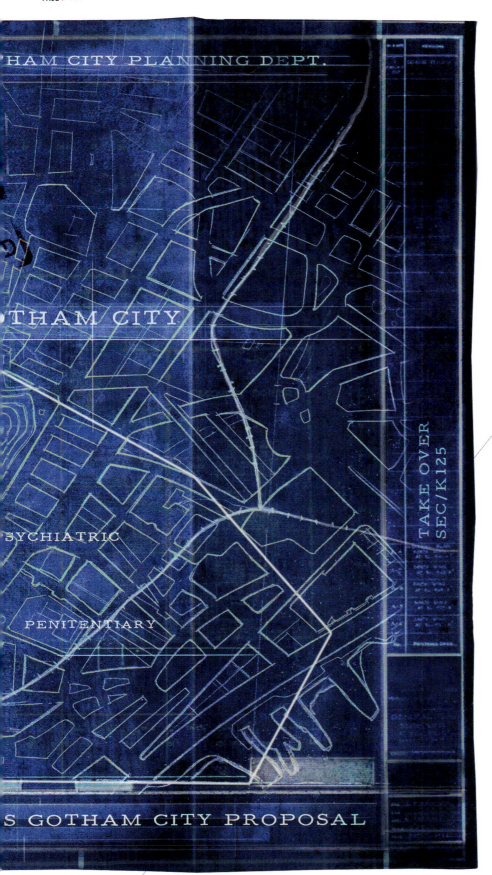

HAM CITY PLANNING DEPT.

OTHAM CITY

SYCHIATRIC

PENITENTIARY

TAKE OVER
SEC/K125

S GOTHAM CITY PROPOSAL

The full scope of *Arkham City* could be experienced through its myriad side missions. In addition, 440 optional "Riddler challenges" (including trompe l'oeil illusions where painted question marks only come into view from precise vantage points) gave players plenty to do.

To traverse this huge world, Batman's cape became a hang glider, while his grapnel gun could draw him toward distant ledges.

The writing team decided to drop a player into Arkham City as an inmate, opening the game with Bruce Wayne's arrest and incarceration. From there, the player follows a main narrative that once again pits Batman against the Joker while enjoying the freedom to explore an entire city full of stories.

"The game's stories aren't just about spectacle, they're about the interdependencies between the characters," says Hill. "Love, hate, anger, and sadness. There's real heart and soul behind them."

LEFT Blueprints for Arkham City, encountered in-game as part of an Easter egg hidden inside the warden's office in *Arkham Asylum*.

ARKHAM INVADES GOTHAM CITY

WHAT DOES GOTHAM CITY LOOK LIKE?
WHAT SHOULD IT LOOK LIKE?

This legendary fictional city has been realized many times in comics and animation, but *Arkham City* was an opportunity to put a new spin on the setting while paying homage to the character's roots.

"We had a lot of positive feedback on the darkness and creepiness of *Arkham Asylum*," says art director David Hego, "such as the way we applied details in every corner and our attempt to stylize character designs through hyperrealism"

"That experience gave us the confidence to take on something bigger. We could finally cross the river from the shores of Arkham Asylum and test ourselves by depicting an open-air prison in Old Gotham City."

Hego's team drew from a grab bag of styles and influences collected over the decades of Batman's fictional history. "The city has been depicted in many different ways in the movies and comics,

from very Gothic and stylized to a more modern take," he says. "It was interesting to try to apply the art direction we developed for *Asylum* into a new ground and show that we could consolidate the Arkhamverse and expand our vision."

The footprint occupied by Arkham City proved to be five times larger than the environment from the first game. With the added real estate, the art team created a city with divergent neighborhoods and a timeless atmosphere. "It feels like a dystopian and anachronistic world, an out-of-time blending of late nineteenth- and early twentieth-century style with a more contemporary influence," says Hego. "It creates a disturbing, peculiar world.

OPPOSITE Kan Muftic created these three depictions of Arkham City's skyline from various angles and at different times of day. The orange tint indicated the presence of industrial pollution but would be toned down in the final game.

ABOVE A Lee Oliver rendition of the gates leading to Arkham Asylum, the setting of the previous game in the series.

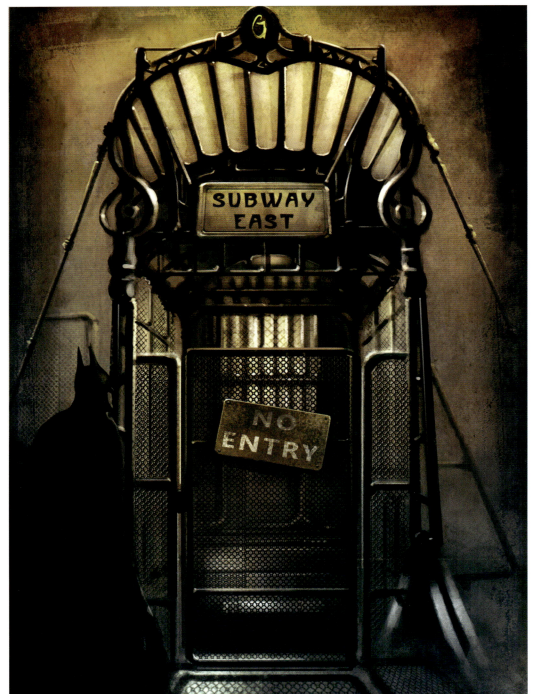

TOP LEFT Lee Oliver's poster depicting Hugo Strange. These propaganda pieces relied on a limited color palette of black, white, and red.

TOP RIGHT The Gothic lines of this traditional church interior emphasize verticality. Art by Kan Muftic.

ABOVE Lee Oliver's light-washed rendition of the wall surrounding the Arkham City complex.

RIGHT The area surrounding the subterranean Wonder City environment contained art nouveau and late nineteenth-century Parisian influences. Art by Lee Oliver.

TOP This ghost train design by Lee Oliver was created for the steel mill/fun-fair setting in which the Joker operates.

ABOVE The area surrounding the subterranean Wonder City environment contained art nouveau and late nineteenth-century Parisian influences. Art by Lee Oliver.

ABOVE, RIGHT A Lee Oliver depiction of the ominous statuary and ornamentation found in Arkham City.

RIGHT Deco-inspired industrial design by Lee Oliver, including a dash of retrofuturism.

TOP, LEFT Poison Ivy's creeping greenery overtakes a deco building in this piece by Kan Muftic.

TOP, CENTER Retro typefaces and design styles found expression on posters like this Iceberg Lounge advertisement.

TOP, RIGHT Lee Oliver's interpretation of the Joker's Funland gates leading into a harsh industrial environment.

ABOVE AND LEFT Ice overtakes the Penguin's Iceberg Lounge as well as the Gotham City Police Department headquarters, where Mr. Freeze is being held. Art by Lee Oliver.

TOP TWO These two pieces by Kan Muftic mix industry with playfulness. The clashing design themes found in the Joker's environment were intended to make players "raise their eyebrows" when taking it all in.

FAR LEFT This stained-glass mural depicts Saint George slaying the dragon but also resembles the crusading Super Hero Azrael. Art by Lee Oliver.

LEFT Lee Oliver's depiction of the church exterior, an oasis amid the chaos of Arkham City.

TOP The exterior of the Cyrus Pinkney museum, with its Victorian architecture, is based loosely on the British Museum. Art by Kan Muftic.

ABOVE AND OPPOSITE, CENTER LEFT The museum's display cabinets have been converted by the Penguin into trophy cases and prison cells. Art by Kan Muftic.

OPPOSITE, TOP A bat-themed exhibit wing and display case. Art by Kan Muftic.

OPPOSITE, CENTER RIGHT Kan Muftic's interpretation of the museum's stuffed mammoth, one of the building's centerpiece exhibits.

OPPOSITE, BOTTOM Detailed view of environmental butterfly signage. Art by Lee Oliver.

LEFT SIDE, TOP TO BOTTOM A subway station beneath Arkham City; An early concept of the Lazarus Pit that restores the frail Rā's al Ghūl to full health; A depiction of the Arkham City courthouse. Two-Face has damaged the statue to ruin its symmetry; Conceptual art of a movie theater environment. On the screen is a moment from a Zorro film, the same film Bruce Wayne viewed on the night his parents were murdered. All art by Kan Muftic.

TOP Statues of Harley Quinn, outfitted with speakers, taunt players as they explore the Joker's realm. Art by Lee Oliver.

ABOVE The pipework and ancient machinery powering the heart of Wonder City. Art by Lee Oliver.

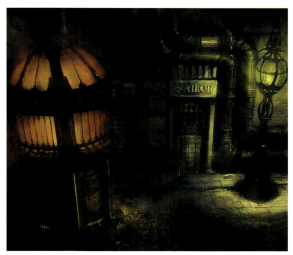

TOP ROW Old-fashioned futurism is on display in this Wonder City poster by Lee Oliver; A view of Gotham City more than a century in the past, depicting Wonder City in its prime. Art by Lee Oliver.

SECOND ROW Lee Oliver studies of potential Wonder Tower architectural shapes, patterned in part after the Eiffel Tower; A Lee Oliver study of a vintage-style Ferris wheel.

THIRD ROW The upper-level viewing platform of Wonder Tower as seen from the inside by Lee Oliver; A poorly lit Wonder City alleyway.

RIGHT Kan Muftic's interpretation of a hazy Arkham City skyline.

TOP ROW This wanted poster of Bruce Wayne bears a Penguin tag at lower right. Art by Lee Oliver; Two facial dissection diagrams, encountered by Batman during one of the game's side missions. Art by Lee Oliver.

ABOVE, LEFT The Flying Graysons poster hints at Nightwing's backstory. Art by Kan Muftic.

ABOVE, RIGHT Two-Face recruits thugs in this parody of the classic U.S. Army poster. Art by Kan Muftic.

THIS PAGE Concept art for the dreamscape in which Batman faces off against Rā's al Ghūl. The shapes and placements of the ruins were meant to evoke a far-future Gotham City devastated by climate change.

A REAL ROGUES GALLERY

DESIGNING THE CHARACTERS INHABITING ARKHAM CITY INVOLVED REFRESHING PREVIOUS MODELS AND EXECUTING FRESH TAKES ON CLASSIC LOOKS.

"'UGLY MEN AND BEAUTIFUL GIRLS' WAS THE BRIEF FOR THE ARKHAM CHARACTERS."

But every resident, new or old, fit instantly into the aesthetic of the Arkhamverse.

"Our style of hyperrealistic stylization was applied to the character design," says David Hego. "The question was how to rethink characters—especially villains, who have an integral part in pop culture—and inject something fresh and contemporary into them."

Pablo Hoyos worked as *Arkham City*'s senior character artist. "By the time we completed *Arkham Asylum* we had established a set of visual rules that defined the Arkham style," he says. "This boiled down to a gritty, stylized realism that leaned toward comic book proportions and aesthetics with realistic rendering of skin and materials.

"We carried that Arkham style onto the new characters by keeping their defining features but grounding them in the reality of our universe—which got even darker and grittier for *Arkham City*."

The rotund business baron known as the Penguin exemplified this signature twisting of accuracy with exaggeration. "Our idea was to extract the Penguin's iconic features, put them in the Arkham blender, and inject them back into the character," says Hego.

"The Penguin is known for his umbrella, his top hat, and his monocle. So we took the monocle and rethought the object itself—what could we

OPPOSITE *Arkham City* promotional art of Batman and Harley Quinn.

RIGHT A portrait of a young Penguin with his parents, the wealthy Cobblepots. Art by Kan Muftic.

Bottom of a bottle,
stabbed into Penguin's eye

Due to the throat cancer,
Penguin has to use a
speaking device

has a split-personality perspective on the events unfolding in Arkham City.

The Riddler taunts the Dark Knight with glowing question-mark trophies scattered across the city. The battle of wits between Batman and the Riddler escalates throughout the game, involving cryptographic puzzle boxes and elaborate death traps.

Some *Arkham Asylum* characters underwent makeovers prior to their return in the sequel. "Harley Quinn changes her outfit—we're not in the asylum anymore," says Hego. "She dropped the nurse cues and moved into an urban version of her jester outfit. It has a modern, more mature take, with leather, high boots, and tattoos."

The emotionally remote Mr. Freeze is a brilliant scientist and an unpredictable ally who helps Batman one moment and turns on him the next. Because Freeze can't survive at normal temperatures, his armor circulates coolant that glows like neon piping.

Rā's al Ghūl is the mastermind behind the construction of Wonder City, but what he really wants is for Batman (or as he calls him, "Detective") to undergo the Demon Trials and take his place as the head of the League of Assassins. His daughter, Talia, shares a troubled romantic history with the Dark Knight.

Bulked-up monsters, such as Clayface and Solomon Grundy, are bosses that must be defeated to pass certain stages.

The Lewis Carroll–obsessed Jervis Tetch is better known as the Mad Hatter. In *Arkham City*, the Hatter drugs Batman and invites him to a demented tea party.

In his capacity as overseer of Arkham City, psychologist Hugo Strange has collected every inmate from both Arkham Asylum and Blackgate Penitentiary. Minor villains whom players can encounter include Calendar Man and the Russian brothers known as Hammer and Sickle. Strange employs private military firm TYGER Security to keep the peace.

Robin makes his first appearance in the Arkhamverse, delivering equipment and supplies to his mentor. His shaved head was inspired by contemporary cage fighters.

The Joker, Two-Face, and the Penguin have armies of thugs outfitted in gang colors that mark their allegiance. Seldom seen are the elusive and deadly ninja assassins who have pledged their lives to Rā's al Ghūl.

replace it with to alter his look while keeping the character recognizable? This is when the idea of the bottom of a broken bottle came up. We encased it over the Penguin's eye socket, twisting the monocle into a more stylized—and somewhat improbable—prop."

Adds Hoyos, "With the Penguin, we wanted to focus on the menacing aspects of his character and push them further. The broken bottle was stuck in his eye socket during a fight, and in the game he tells the story about how that happened and what he did to the guy who put it there. It only makes him more evil and dangerous."

Catwoman, Gotham City's morally gray jewel thief, debuted in *Arkham City* as a playable character with a storyline of her own. True to her fickle feline nature, Catwoman can opt to either aid Batman in his quest or to skip town and enjoy her ill-gotten gains.

"'Ugly men and beautiful girls' was the brief for the Arkham characters," says Hego. "Ugly and muscular thugs would fight Batman, while beautiful girls would confront him. Catwoman, Harley Quinn, and Talia al Ghūl were depicted as archetypal comics villains, in line with the extravagant, exaggerated world we were creating.

"Catwoman's design is quite straightforward, with the expected cat suit. A lot of work was done on the material pattern and construction line. It gives it a modern and quite techy feel while remaining sexy."

At the start of the game, Catwoman double-crosses Two-Face and nearly loses her life when he takes his revenge. Two-Face, with his bisected costume and obsession with duality,

ABOVE An early character concept for the Penguin by Kan Muftic. Ultimately the Penguin would have a more businesslike look.

OPPOSITE An *Arkham City* promotional piece featuring the final design of the Penguin.

OPPOSITE A Catwoman portrait created as promotional art for the *Arkham City* release.

TOP An in-game render depicting Catwoman's movement style.

ABOVE, LEFT Kan Muftic art exploring ways in which Catwoman could navigate the environment that Batman would not.

ABOVE, RIGHT Catwoman is held prisoner by Two-Face in this piece by Kan Muftic.

RIGHT A playful character study of Catwoman by Kan Muftic. The team knew she needed to be less serious than Batman.

'Typical. We are here to try the defendant."

"Guilty 'til proved innocent. Kill her!"

"Bring her out!"

OPPOSITE, TOP Lee Oliver concepts for a glowing-neon "Riddler trophy" and a puzzle box used to decipher cryptogram clues.

OPPOSITE, BOTTOM The Riddler played a role in *Arkham Asylum*, but wasn't seen in-game until *Arkham City*. These concepts by Kan Muftic include a "goth" design with loose-fitting clothing and buckles.

LEFT Kan Muftic storyboard art depicting Two-Face's internal struggle.

TOP Two-Face flanked by thugs. In early concepts, some thugs would bear gruesome mutilations. Art by Kan Muftic.

ABOVE Another Kan Muftic concept for Two-Face.

TOP A Lee Oliver study of Harley Quinn's oversize pistol, complete with lucky dice.

ABOVE, LEFT Harley Quinn's diploma, encountered in the game as a way to build an unspoken backstory.

ABOVE, RIGHT A Kan Muftic character concept for Harley exploring the jester aspects of her costume.

ABOVE Kan Muftic art of a more urbanized Harley, dropping the nurse elements from her previous costume.

RIGHT A final render of Harley Quinn produced for marketing purposes.

TOP AND ABOVE, LEFT Three concepts by Kan Muftic for Mr. Freeze, depicting him with and without his armor. The art team wanted to emphasize Freeze's vulnerability.

ABOVE, RIGHT Mr. Freeze's containment cell, set to a high temperature as an instrument of torture. Art by Lee Oliver.

TOP, LEFT Character concept for Rā's al Ghūl. Art by Kan Muftic.

TOP, RIGHT Kan Muftic's early concept depicting Rā's al Ghūl's immersion in a life-extending Lazarus Pit.

ABOVE, LEFT Rā's al Ghūl is flanked by female members of the League of Assassins in this piece by Kan Muftic.

ABOVE, RIGHT A Lee Oliver poster advertising the abilities of the undead Solomon Grundy, done in the style of an old-fashioned carnival notice.

OPPOSITE, TOP One concept involved Clayface swallowing Batman, requiring the Dark Knight to cut his way out from the inside. Art by Kan Muftic.

OPPOSITE, CENTER An early Clayface design by Kan Muftic; An impressionistic piece by Kan Muftic depicting Batman's boss battle with Solomon Grundy.

OPPOSITE, BOTTOM Two pieces by Kan Muftic, one completed extremely early in game development, exploring a nightmarish encounter with the Mad Hatter; the other a concept of Solomon Grundy, intentionally playing up the creature's similarity to Frankenstein's Monster.

TOP, LEFT The Mad Hatter's surreal tea party begins. Art by Kan Muftic.

TOP, RIGHT Batman fights the Mad Hatter atop a falling pocket watch in this piece by Lee Oliver.

ABOVE A Mad Hatter environmental concept by Lee Oliver. In this version, a shrunken Batman would encounter oversize tea party place settings.

RIGHT The final design of the Riddler, created for marketing purposes.

OPPOSITE A marketing piece depicting Robin. The art department gave Robin a shaved head to make him look tougher, as well as a suit that shared some of the same design elements as Batman's.

TYGER GUARD
KAN '10

color of the uniform

material of the gloves

boots reference

OPPOSITE, TOP, LEFT TO RIGHT Calendar Man, a minor Batman villain; A thug allied with Two-Face, half his body mutilated by acid; A concept for a Penguin-allied thug. All art by Kan Muftic.

OPPOSITE, BOTTOM A TYGER security officer is seen in this piece by Kan Muftic. Inspired by the privatization of U.S. prisons, the art team went for a paramilitary look.

TOP, LEFT TO RIGHT Hugo Strange is depicted in this character study; Concepts for Hammer and Sickle, Soviet-themed villains working as enforcers for Arkham City crime bosses. Art by Kan Muftic.

ABOVE Kan Muftic concepts for various Joker-allied thugs found within Arkham City. The apron-wearing blacksmith concept proved too difficult to animate using character models.

RIGHT Kan Muftic's character design for the Joker—very similar to the final design selected for the game.

OPPOSITE Art created for the marketing of *Arkham City*.

FOLLOWING SPREAD Catwoman and Batman are entwined in this promotional art for *Arkham City*.

GEARING UP

PLAYERS START ARKHAM CITY ARMED WITH A FEW SELECT GADGETS, **BUT SOON BATMAN'S BUTLER, ALFRED, DELIVERS AN ARSENAL VIA AIRDROP.**

The transformation from Bruce Wayne into the Dark Knight is satisfying and empowering, and for players weaned on *Arkham Asylum*, the gadgets are familiar.

The Batarang, line launcher, grapnel gun, and explosive gel wear the metallic, machined lines indicating their origins as products of WayneTech. A cryptographic sequencer can hack security consoles and monitor shortwave radio channels.

Arkham City expands Batman's utility belt with smoke bombs, a freeze jammer, a gun that delivers electrical charges, and a disruptor capable of remotely disabling guns and mines. The detective mode from *Arkham Asylum* underwent a redesign that made the screen blur when Batman is struck by an enemy.

Catwoman uses a completely different style of combat, one that emphasizes agility and acrobatics. Her weapons include spiky caltrops, entangling bolas, and her signature whip.

Batman's sidekick, Robin (Tim Drake), is a playable character in stand-alone challenge maps, as is Nightwing (Dick Grayson)—formerly the original Robin, and now a hero in his own right. Robin's bō staff incorporates an extendable shield. Nightwing uses Batarang-like throwing blades and a pair of escrima sticks.

OPPOSITE Lee Oliver renditions of Batman's grapnel gun and equipment pod.

RIGHT An injector and a line launcher are seen in these equipment studies by Lee Oliver.

BATMANS FREEZE JAMMER

01

02

03

04

LEFT, TOP TO BOTTOM Catwoman's caltrops, bolas, and bullwhip are seen in these studies by Lee Oliver. Unlike the sleek WayneTech lines found in Batman's equipment, Catwoman's gear feels more homemade.

RIGHT, TOP TO BOTTOM Freeze jammer deployed by Batman; The freeze

Clayface Movement

Clayface Jab

Clayface Ground Slam

moving across a big distance

Normal guard

Leaning backwards, preparing the punch

Pushing forwards, punching diagonally from above

PROGRAMMING ARKHAM CITY

ARKHAM CITY OFFERED ITS DEVELOPERS **AN OPEN-WORLD CANVAS** THAT ALTERED THE APPROACH TO GAMEPLAY.

" IN ARKHAM CITY, THE NUMBER OF ANIMATIONS NEARLY DOUBLED. "

The sweeping, three-dimensional interplay of alleyways and rooftop architecture was built block by block. The city's broken terrain wouldn't have made sense for the Batmobile; instead, Batman would glide overhead using his cape.

Arkham City has been walled off to the outside world, but it is still populated by roving gangs and skulking political prisoners.

Lead animator Zafer Coban knew how important it was to keep the character animations unique and minimize repeat actions. "With every installment we reevaluated our animations to see what we could do better, or to swap a few out with brand-new ones," he says. In *Arkham City*, the number of animations nearly doubled, reflecting the wider range of moves at the player's disposal.

"For combat, coming up with new moves was a challenge, as we had already pushed the boat out as far as we could," says Coban. "But we understood the need." An improved version of *Arkham Asylum*'s Freeflow combat system allowed players to counter multiple blows simultaneously, catch hurled projectiles, and attack from the air.

"Luckily we've got a few guys on the animation team who are martial arts buffs," says Coban. "Consulting with them is a real pleasure."

OPPOSITE Kan Muftic produced these animation references for the movements of Clayface and Arkham City's belligerent thugs.

RIGHT Batman in action. Art by Kan Muftic.

LAST DANCE

ARKHAM CITY ENDS WITH A SHOCKING SHOWDOWN BETWEEN BATMAN AND THE JOKER.

"
THAT IMAGE AT THE END OF THE GAME . . . WAS ACTUALLY OUR STARTING POINT, AND WE WORKED BACK FROM THERE.
"

Out of the many tales starring the Dark Knight, the game's narrative twist earns special notice for its willingness to take the battle to its ultimate conclusion.

"What worked for us [during writing] is this image that we became quite fixated upon: Batman carrying the Joker's lifeless body," recalls Sefton Hill. "It drove us to think about the events that would lead up to that moment, and what Batman's reaction would be."

In the game, a dying Joker infects Batman with his own, toxic blood. Not only does this unite the two characters in symbolic brotherhood, it introduces a ticking-clock element to Batman's quest.

"The driving factor became the bond between Batman and the Joker as they both strove for the same objective: to find the cure for their sickness," says Hill. "That image at the end of the game—when Batman is walking out of the Monarch Theatre with his greatest enemy dead in his arms—was actually our starting point, and we worked back from there."

Ultimately Batman is willing to cure his foe, but the Joker backstabs him in an act of hatred and spite. The vial containing the cure smashes, and the Joker succumbs to his illness.

"The Joker is responsible for his own downfall," says Hill. "He couldn't resist the opportunity to strike out and attack when he saw Batman at his weakest. His death is his own fault, but his choices make sense in view of his motivations. He just can't help himself when presented with that sort of opportunity."

The death of the Joker was the culmination of events set in motion in the first game—a factor that contributes to the verisimilitude of the Arkhamverse. "It's important to us that each game changes the universe in some way," says Hill. "At the end of *Arkham Asylum* we have the Joker overdosing on the Titan formula, and in *Arkham City* we find out that he's paying the price and it's slowly killing him."

The abrupt end of the symbiotic relationship between the Joker and Batman wasn't the end of the Arkham saga. As conceived by Hill, the fall of Gotham City's crime king would have major implications for the third and final Arkham game.

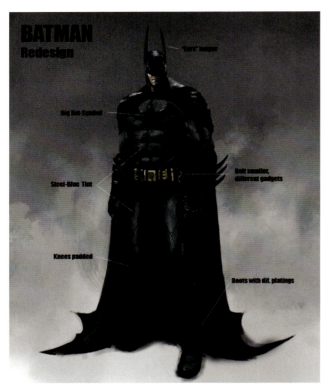

BATMAN
Redesign

"Ears" longer

Big Bat-Symbol

Belt smaller, different gadgets

Steel-Blue Tint

Knees padded

Boots with dif. platings

ARKHAM CITY: THE RECEPTION

IN MAY 2011, THE ARKHAM SERIES WENT BACK TO ITS THEMATIC ROOTS WITH THE FIRST ISSUE OF BATMAN: ARKHAM CITY,

a five-part comic book series by Paul Dini (co-writer of *Arkham Asylum* and *Arkham City*) and Carlos D'Anda (conceptual artist on *Arkham Asylum*). "There were moments where I had to pinch myself and realize what a trippy loop I was in," says D'Anda. "I had designed a game based on a comic, and now I was drawing a comic based on the game."

The game made its debut on October 13, 2011, in North America, with the Australian and European releases following over the next several days. The response was incredible. Worldwide, *Arkham City* sold two million units in its first week, making it one of the fastest-selling games ever.

Near-universal critical acclaim supported the popular consensus that Rocksteady had surpassed *Arkham Asylum*'s high-water marks in every way. Game Informer gave *Arkham City* a perfect score of ten, calling it "the best licensed video game ever made." The game racked up four wins at the 2011 Spike Video Game Awards

and two more from the British Academy of Film and Television.

The Collector's Edition of *Batman: Arkham City* came packed with extras, including an art book, a soundtrack album, downloadable skins and challenge maps, a copy of the animated film *Batman: Gotham Knight*, and a monochromatic Batman statue from Kotobukiya.

For Rocksteady, the accolades were satisfying, if perhaps a bit premature. The team had a story to tell, and it would take one more game to bring about the planned conclusion of the Arkham-verse.

OPPOSITE, TOP LEFT A render with paintover elements, experimenting with variations on Batman's design. The elongated ears did not make it into the final version.

OPPOSITE, TOP RIGHT A moody character study of Batman by Kan Muftic.

OPPOSITE, BOTTOM LEFT The final version of the Joker as seen in *Arkham City*.

OPPOSITE, BOTTOM RIGHT Batman confronts the Joker in this piece by Kan Muftic.

RIGHT This piece by Kan Muftic depicts the confrontation inside Wonder Tower and showcases the environment's art nouveau influences.

THIS SPREAD Another artist, Lee Oliver, gives his take on the confrontation inside the Wonder Tower.

ARKHAM SCORE

HOW DOES ONE DEVELOP AN IMMERSIVE SOUNDSCAPE?

How can a game's score convey tension, regret, or foreboding? Nick Arundel, who composed the music for *Arkham Asylum* and *Arkham City* with Ron Fish, has some ideas.

"In terms of immersion, we always start with the environment," says Arundel. "Do the city and interiors sound believable? We spent days recording various city perspectives—mainly in America—to create the palette of background sounds used throughout the Arkham games.

"We recorded in deserts, on city streets, and at the top of skyscrapers. Caves, a museum, a brewery, and parking structures by the handful. City parks, offices and air-conditioning units, abandoned warehouses, building sites, and the LA river. Helicopters, trains, and distant cars. Under bridges, on top of bridges, and the waves crashing onto a beach at four a.m.

"We do this not to create a kind of documentary-style reality, but a level of believability," he continues. "It would be easy to pull that from commercial libraries, but we don't want our game to sound like another game. We want it to sound unique, and to be the perfect aural accompaniment to the visuals.

"The sounds have to convince the listener that they are the sounds of Gotham City. We spent many days editing and manipulating the recordings so that they would work alongside the art style for the game."

The Arkham games feature an orchestral score that incorporates synthetic elements. The combination of the organic with the artificial, says Arundel, exemplifies the spirit of this particular fictional world.

"Batman is a combination of human and technology. He has amazing gadgets at the cutting edge of technology, but ultimately he's just a man. We wanted to reflect this in the music by combining the more traditional orchestral elements—to reflect Batman's humanity—and the more high-tech elements that help separate Batman from the rest of us."

This mix evolved over time, from *Asylum* to *City* to *Knight*. "Initially we started with a very clear distinction between the traditional instruments and the synths," says Arundel. "Over the course of the Arkham projects, that line blurred. In *Arkham Knight*, very often it's difficult to tell if you're listening to a synth or an orchestral gesture."

The main characters possess signature leitmotifs—a musical technique that heralds their arrivals and summarizes the essence of their personalities. The Joker, Poison Ivy, and Batman don't look the same, and they shouldn't sound the same.

ABOVE An Arkham City concept by Kan Muftic, emphasizing Victorian architecture. This pointed-roof style was rejected due to the difficulty of player navigation.

"Early in the project I was concerned with ensuring that the music sounded coherent, like one set of interrelated tracks," says Arundel. "All the music is based around a short five-note melody, which is, by and large, referred to as the 'Batman Theme.'

"I wanted each new character to reflect some aspect of Batman and not have a completely new set of music. Each character has their own variation on that five-note melody. The Joker's melodic material is just one note different than Batman's. Catwoman's music is Batman's music turned upside down—every time the melody moves up in the Batman Theme, it moves down for Catwoman.

"I wanted to have a very clear set of chords and harmonic movements that remained constant across the projects," he adds. "In fact, we have just one A4 piece of manuscript that contains all the elements—the DNA—of all three scores. You could hand that manuscript to another composer and that could form the basis of a whole new Arkham score."

The choice of instruments in the score delivers thematic and emotional impact and carries into the structure of Arundel's limited leitmotifs.

"We draw strong associations between instrumentation and rhythm with particular characters," he says. "Batman is linked with string and synth ostinatos, and Ivy to female singers. The Joker is often associated with aleatoric rhythms with string and piano clusters."

Arkham Asylum didn't get an official soundtrack release, but *Batman: Arkham City—Original Video Game Score* appeared on October 18, 2011. The album, from Water-Tower Music, contained nineteen selections from the Nick Arundel/Ron Fish team, with tracks titled "Sorry, Boys," "Let's Hear Him Squeal," and "You Should Have Listened to My Warning."

WaterTower Music also published *Batman: Arkham City—The Album* at the same time. This collection of popular music featured such offerings as "Mercenary" by Panic! at the Disco, Coheed and Cambria's "Deranged," and "Shadow on the Run" from Black Rebel Motorcycle Club.

PART //4
ARKHAM KNIGHT

GOTHAM CITY HAS RECOVERED FROM ITS STINT **AS A WALLED-OFF SUPER-PRISON AND WEARS A NEW, VIBRANT SKIN BY THE TIME ARKHAM KNIGHT BEGINS.**

> **"**
> **NOW, WITH ALL THE VILLAINS UNITED, IT'S THE GREATEST CHALLENGE BATMAN HAS EVER FACED.**
> **"**

But the city's power structure hasn't recovered from the loss of the Joker, and the final act of the Arkham trilogy demonstrates that Gotham City can never purge the evil that stems from its infamous madhouse.

"With the Joker dying at the end of *Arkham City*, we immediately felt that there was a very interesting dynamic going into *Knight*," explains director Sefton Hill. "The Joker is a chaotic force that keeps the enemies of Batman fighting against each other. He's the random element.

"With the Joker removed from that picture, the villains have aligned themselves in a way they could never do before. While he was alive, the Joker saw Batman as his plaything. He would prevent the other villains from working together because he didn't want to share Batman with anyone else.

"*Arkham Knight* represents the ultimate struggle for Batman, because it's all the villains working together for the first time. In *Arkham City* they were all taking on each other, which was something Batman could use to his advantage. Now, with all the villains united, it's the greatest challenge Batman has ever faced."

PREVIOUS SPREAD An in-game screenshot of Batman from *Arkham Knight*.

OPPOSITE An in-game render of Batman's final design. Batman's armor received a head-to-toe redesign to reflect advances in technology.

RIGHT A Kan Muftic concept of the military-led operation to empty Gotham City of civilians in response to Scarecrow's terrorist threats.

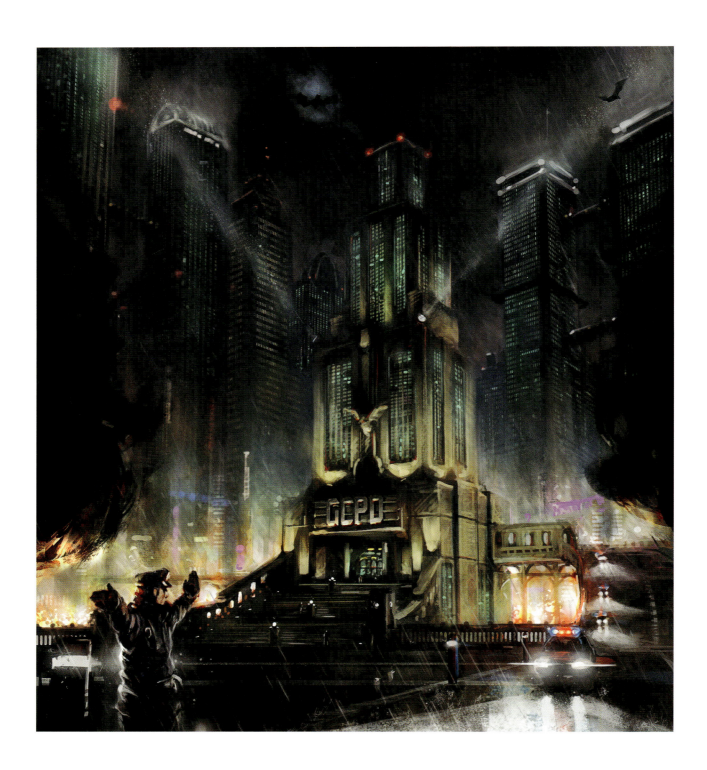

THE GATHERING STORM

SENIOR SCRIPTWRITER **MARTIN LANCASTER** **DEVELOPED THE STORY FOR ARKHAM KNIGHT** **ALONGSIDE SEFTON HILL.**

"MILLIONS OF CIVILIANS FLEE GOTHAM CITY, LEAVING ONLY CRIMINALS AND THRILL SEEKERS BEHIND IN AN ENVIRONMENT WHERE THE POLICE HAVE LOST CONTROL."

OPPOSITE Early version of the G.C.P.D. building. It will end up being a lot bigger to create a more noticeable landmark in Gotham City's vista. Art by Oliver Odmark.

BELOW A Lee Oliver experiment with lighting and color. The art team strove to create layered levels of Gotham City, making it a more exciting player environment.

The bold decision to eliminate the Joker in the second act was, he explains, a critical narrative choice that allowed the finale to unfold in proper fashion.

"The Joker was the star of the previous games, a wild card who took center stage and constantly demanded Batman's attention," says Lancaster. "He's such a significant character in the Arkhamverse that his death had a huge impact on Batman and Gotham City as a whole. Batman was coming to terms with his guilt over the death of his archnemesis. Crime hit an all-time low while the villains regrouped and plotted to fill the void."

But with no Joker at center stage, another supervillain would have to be the first to step into the spotlight. "Who better to exploit Batman's weakened psychological state than Scarecrow?" says Lancaster.

The terror-twisting Scarecrow deploys neurohallucinogens to send his victims into spasms of fear. "Scarecrow is able to leverage villains to cooperate and attack Batman on all fronts," says Lancaster. "Without the court jester's distractions, the other villains get organized to take down the Bat."

The Penguin, the Riddler, Two-Face, and Harley Quinn all throw their lot in with Scarecrow; only Poison Ivy refuses. On Halloween, Scarecrow unleashes a sample of fear gas and threatens to release even more the next day. Millions of civilians flee Gotham City, leaving only criminals and thrill seekers behind in an environment where the police have lost control.

After Gotham City falls under lockdown, the residents of the city seem to have lost their hard-won hope. Batman takes on the burden of restoring their faith.

"Scarecrow and the others launch a coordinated attack, striking fear into Gotham City's citizens and transforming the city into their domain," says Lancaster. "Batman has always been Gotham City's symbol of hope, and this is the very idea that Scarecrow wants to eradicate."

VILLAINS UNITED

CLASSIC BATMAN VILLAINS ABOUND IN ARKHAM KNIGHT, INCLUDING THE PENGUIN, TWO-FACE, SCARECROW, AND THE RIDDLER.

WE WANT THE PLAYER TO SEE HOW A VILLAIN HAS BEEN AFFECTED BY EVENTS FROM A PREVIOUS GAME, AND TRANSCRIBE THAT INTO AN UPDATED DESIGN.

They may be working together, but their motivations and methods are very different.

"The previous Arkham games established clear rivalries between Batman and his villains," says Martin Lancaster. "In *Arkham Knight*, these rivalries come to a head. The villains have their own reasons for wanting Batman gone.

"The Penguin and Two-Face still have unfinished business. They see Batman as an impediment to their ambitions, and Two-Face's past gives his grudge a more personal edge. The Riddler's fixation with proving his superiority over Batman culminates in his most ambitious scheme yet. And Scarecrow has studied Batman for years, obsessing over what he represents, and is determined to dismantle his myth piece by piece."

Albert Feliu, lead character artist on *Arkham Knight*, perfected the "stylized realism" design philosophy established in the previous games. "We always aim to get a realistic result in the anatomy of our models and the quality of our textures and shaders," he says. "Once we're happy with these, we bring some of the stylization back.

"It's easy to see if someone looks too realistic or cartoony, because it clashes with the characters and the environment. After a few projects, we've managed to be very confident about the art direction of the characters in the Arkhamverse."

According to art director David Hego, the characters need to evolve in concert with the wider story of Arkham. "We want the player to see how a villain has been affected by events from a previous game, and transcribe that into an updated design. Some are just aesthetic, while other details highlight something that changed in the character's life.

The Penguin, for example, "shaved his head, dropped his jacket, and became less of a carica-

ture," in Hego's view. Two-Face is also back in action, executing a brazenly daring bank heist that forces Batman to take him down.

Harley Quinn returns, sporting yet another all-new look. "Harley evolved again—this time into a mourning widow," says Hego. "Her outfit became darker. She felt more sinister and maybe more feminine, wearing a skirt and a hint of Gothic Lolita."

One classic Batman villain, the pyromaniac called Firefly, makes his first Arkhamverse appearance. Firefly unleashes blazing streams from his flamethrowers and uses a turbine-driven backpack to hover like his namesake.

Azrael is driven by a religious zeal to fight crime, but often goes too far for Batman's liking.

Batman's armor is both real and psychological. His relationships with Jim Gordon and his niece Barbara help humanize this emotionally remote protagonist. Barbara Gordon moonlights as the info-broker Oracle, operating from a Gotham City clock tower and remotely whispering advice and updates into Batman's ear.

"We wanted to explore a more personal side to Batman's character through his relationships with his closest allies," says Lancaster. "Jim Gordon and Oracle have complex emotional ties to Batman. This was fertile dramatic ground, especially when we put these characters in situations where their professional aspirations clash with their personal relationships. Batman isn't just defined by the villains he faces, but by the allies who follow him into battle."

Two more allies are Robin and Nightwing. Both characters received design upgrades for *Arkham Knight*.

OPPOSITE In-game shots of Two-Face and the Penguin, showcasing the costume redesigns for each. The Penguin received a gangster-inspired makeover.

RIGHT A Richard Anderson character concept for Poison Ivy, experimenting with new applications for living plants.

Batman has a new look too. "When starting each Arkham game, there is always the need to apply what we learned from the previous project to the next one," says David Hego. "It is even more relevant for the characters—the character team never stops pushing the boundaries of realism and detail. We ended up making an updated version of Batman, implementing the new breakthrough techniques."

For *Arkham Knight*, Batman's new costume incorporates similar shapes and textures to those used in the design of his famous ride.

"The technological jump in rendering between *Arkham City* and *Arkham Knight* made the legacy Batsuit feel a bit lacking in detail," says Hego, "so it was decided to create a new version more in harmony with the Batmobile. The Batsuit became more aggressive—reinforced to sustain Batman's new abilities, but also to reboot certain aspects that were becoming obsolete."

One of these rebooted elements was Batman's cape. Hego reconsidered how it should fasten to the suit. "The older version, where it looks stitched to the cowl, felt very theatrical," he says. "In the new suit, the cape's attachment makes more sense structurally and looks like it could take the forces exerted on it while dive-bombing, or while ejecting from the Batmobile."

New details cropped up around Batman's neck, on his belt and gauntlets, and on his boots. "The details are made more visually exciting with the power of the [next generation] consoles," says Hego.

The Arkham Knight is the game's titular villain, and a character who has a surprising connection to the Dark Knight. His armor is clearly inspired by Batman's, yet his willingness to wield guns is a tip-off that he has strayed far from Batman's example.

"We hope that when a player sees our characters and takes control of Batman, they feel like the characters and the environment act in synergy," says Albert Feliu. "That the character style blends with the buildings and the rain and the smoke. That everything works in unison, and that nothing strikes them as off style."

TOP Military vehicles roll through the darkened streets of Gotham City. Art by Lee Oliver.

ABOVE, LEFT Early concept depicting the evacuation of the city by Kan Muftic. The lost teddy bear adds an emotional link and visual backstory.

ABOVE, RIGHT Concept research of the dock and harbor area of Gotham City. There was talk of putting the Stagg secret lab in a boat before going for an airship. Art by Kan Muftic.

RIGHT A nighttime view of the deserted Gotham Studios. Art by Lee Oliver.

ABOVE Riddler character designs by Oliver Odmark.

LEFT Oliver Odmark designs for a puzzle-like Riddler challenge.

OPPOSITE, TOP A Harley Quinn character study, produced by the German concept company Sixmorevodka.

OPPOSITE, BOTTOM Lee Oliver's design for a taped-together Harley Quinn weapon.

THIS SPREAD A Sixmorevodka design for Firefly, a lesser-known Batman villain. His flamethrower and jet pack were envisioned as coming from "six years into the future."

GUN HARNESS
VISIBLE
UNDER JACKET

POLICE PATCH
AVALIABLE IN
'FINAL CONCEPT'
FOLDER

GCPD

JAMES
GORDON

STUBBLE

GUN HARNESS

RAIN JACKET

LOOSE FIT
T-SHIRT

FINGERLESS
GLOVES

OPPOSITE A near-final Azrael design. Art by the Sixmorevodka studio.

TOP A giant Bat-Signal blazes on a rooftop while Commissioner Gordon looks on. Art by Kan Muftic.

ABOVE, LEFT Commissioner Gordon is seen in this design by Oliver Odmark.

ABOVE, RIGHT Barbara Gordon, who provides information to Batman in her role as Oracle. Art by Oliver Odmark.

FOLLOWING SPREAD An in-game render from *Arkham Knight* spotlighting Batman and Commissioner Gordon's mutual respect.

OPPOSITE The *Arkham Knight* version of Robin, only slightly changed from the previous game through improvements in his body armor.

ABOVE Front and back studies of Nightwing. The art team didn't want to "reinvent the wheel" when it came to character design, instead looking for ways to add detail that felt like a natural evolution.

TOP In-game detail of Batman's new cape-fastening arrangement. The improved capabilities of next-gen gaming systems allow for subtle enhancements such as these.

ABOVE Rear views of the upgraded Batman, with and without his cape. The interlocking pieces of the new body armor bore some similarities to the bulletproof chassis of the Batmobile.

OPPOSITE A near-final rendition of Batman's improved armor, created for marketing use.

THIS SPREAD Views of Batman, developed by the Sixmorevodka studio for marketing use on *Arkham Knight*.

FOLLOWING SPREAD In-game rendering with paintover elements depicting Batman against the neon background of Gotham City's Chinatown district.

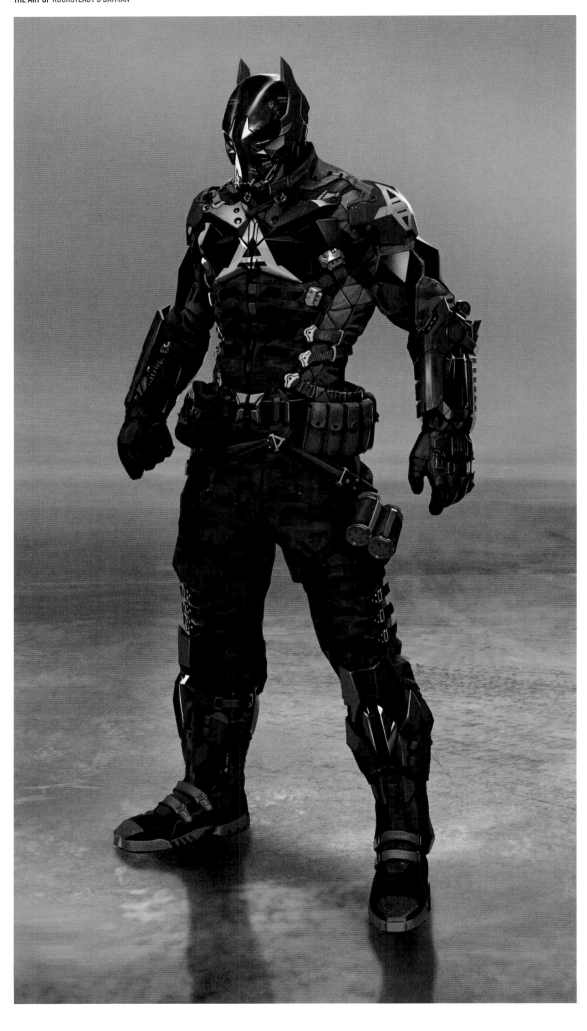

LEFT Character concept by Sixmorevodka for the game's brand-new villain, the Arkham Knight.

OPPOSITE In-game render of the Arkham Knight. The art department viewed him as a military commander, using the colors of his armor to create camouflage patterns.

FOLLOWING SPREAD In-game action shot of the Arkham Knight. Unlike Batman, this new villain does not have any compunctions about using firearms.

PS - The chinese signs are nonsense

TRUE GOTHAM CITY

AT LAST, ROCKSTEADY CAN TRULY SAY,
"WELCOME TO GOTHAM CITY."

PREVIOUS SPREAD The Arkham Knight has his opponent at his mercy in this in-game render with paintover elements.

OPPOSITE Lee Oliver's conceptual study of Gotham City's dramatic urban verticality.

ABOVE An in-game render with paintover elements by Oliver Odmark. Architectural variety allowed the team to create visual landmarks rather than forcing the player to rely on the in-game map.

With each game in the trilogy, the playing field has grown larger, and *Arkham Knight*'s vision of a living, breathing Gotham City has room for both dimly lit street corners and high-speed straightaways.

The environment of Gotham City brought a new set of design challenges. The city needed to evoke everything that had come before while feeling brighter, broader, and faster. And Batman couldn't get too comfortable in his hometown, not while his enemies schemed to make him an outsider.

"The streets of central Gotham City create a very different feel than in *Arkham City*," explains Sefton Hill. "All of the events are focused on destroying Batman and turning the city against him. The point of the occupation is to break Batman, to take everything that Batman loves in Gotham City and use it as a weapon."

Gotham City's new central zone consists of three islands, with a total area approximately five times larger than *Arkham City*'s territory. Art director David Hego needed to build Gotham City anew.

"When moving from *Arkham City* to *Arkham Knight*, the goal was not to just make a bigger version of the game world," he says. 'We needed to understand how we could make the same visual transition that we did between the first

two games. We needed to keep moving forward, to keep pushing the envelope and improving the richness of the Arkhamverse."

Hego tackled the monumental task by planning his virtual city in sections.

"The city would be built in three layers," he says. "The first layer is the building structure with its architectural theme. A second layer of neon signs, billboards, and metal structures can then be bolted to it, to reinforce consumerism and the stereotypical 'American big city.' A third layer of statues and sculptures can be attached to the rooftops and extruding from the walls, to alter the silhouette of the city and give it a distinct look.'

Says Hego, "The first goal was to move from Old Gotham City to Downtown Gotham City, from average brownstone buildings to neo-Gothic vertiginous skyscrapers. Then we had to project ourselves into being a citizen. How did it feel to live in Gotham City? The architecture continued to mature in that neo-Gothic mix we were comfortable with, but a lot of emphasis was put into making the city feel alive."

The city's aesthetic spans the decades to feel timeless, despite an omnipresent vibe of dystopian menace.

"From billboards to shop signs, literally hundreds of brands were created to make Gotham City feel believable," says Hego. "Some were taken from Batman's universe or from the DC Comics universe. Some were created to fit with the story. A massive amount were added to fill the gaps, and to make each street corner unique."

Detail is more important than scale. This Gotham City needed to be both dense and vibrant, bringing to life the most evocative pieces of concept art.

ACE Chemicals is a cavernous industrial plant swimming in poisons. This major game environment serves as a hideout for the Arkham Knight.

In the soundstages of Penessa Studios (formerly Gotham Studios), sci-fi and Old West backdrops lend an eerie air to a facility that has seen better days.

"We populated the Gotham City streets with cars," says Hego. "We picked the style of the cars in an Americana flavor, resonating with iconic cars from the fifties, sixties, and seventies to create that 'out of time' feel."

Above the streets, zeppelins and parade balloons add a vertical dimension to the environment.

As in the two previous games, Poison Ivy has a significant part to play. Yet she can't abide a concrete jungle. Ivy's pet plants soon overtake gray urban slabs and set down roots for their leafy tendrils.

Meanwhile, villain factions and random looters try to tear the city apart. "The rioters and the thugs are just going in there and trying to take whatever they can while the city is weakened," says Hill. "Scarecrow encourages this conflict on the street as part of his coordinated attack."

helipad

ABOVE Architectural details for Gotham City buildings. As seen in the previous game, Gotham City would include a mix of historical styles, including 1930s art deco.

RIGHT Exterior study of the Gotham City Police Department headquarters, specifying points of interest and including a scaled Batman for developer reference.

batsignal
projector

GCPD
sign/eagle

ABOVE An Oliver Odmark concept for the exterior of the Gotham City Police Department headquarters.

OPPOSITE, TOP LEFT Concept research for the entrance of Wayne Enterprises, playing around with art deco architecture, by Lee Oliver.

OPPOSITE, BOTTOM LEFT Early concept of the G.C.P.D. building by Lee Oliver.

OPPOSITE, RIGHT The Wayne Tower is seen in this concept by Oliver Odmark. The building's height and apparent age attest to the Wayne family's generations-long influence in Gotham City affairs.

ABOVE A street-level view shows that much of the action in Gotham City happens overhead. Art by Oliver Odmark.

CENTER, LEFT A Kan Muftic concept of the Gotham City skyline and the elevated highways leading into the heart of downtown.

LEFT A cargo freighter waits at the Gotham City Harbor docks in this gloomily lit piece by Kan Muftic.

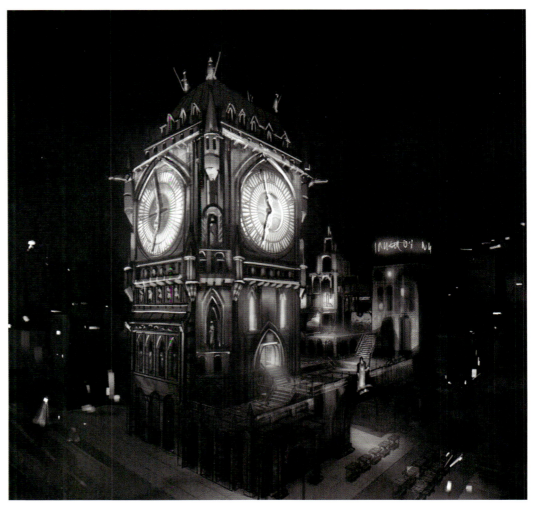

ABOVE: Kan Muftic's concept of a spacious interior environment akin to New York City's Grand Central Station.

RIGHT: A Kan Muftic concept of a Big Ben–inspired Gotham City landmark, rejected for looking too short and squat.

TOP A Kan Muftic concept of a bat's-eye view on Gotham City, seen while players are gliding from point to point.

CENTER The intersection of elevated bridges provides visual variety and an invitation to explore. Art by Kan Muftic.

LEFT The Batmobile heads into Gotham City's Chinatown district, its headlights adding to the area's omnipresent neon glow. Art by Kan Muftic.

TOP The interior of a toy store looks far from welcoming in this piece by Kan Muftic.

RIGHT Lady Gotham is encountered on an island in Gotham City Harbor in this world's blindfolded equivalent of the Statue of Liberty. Art by Oliver Odmark.

ABOVE An Oliver Odmark piece for a carved tunnel entrance.

RIGHT Extreme gargoyle ornamentation is seen in this concept by Oliver Odmark.

OPPOSITE Batman stands atop an outsized public monument. Art by Oliver Odmark.

TOP The central cluster of buildings for the Ace Chemicals facility, captured in this piece by Kan Muftic.

ABOVE, LEFT The Ace Chemicals environment is surrounded by choppy water on all sides, making the dangerous setting seem even more hostile.

ABOVE, RIGHT The interior of Ace Chemicals is swimming with toxins and corrosives. Art by Lee Oliver.

LEFT The use of bright orange suggests the presence of hazardous waste. Art by Kan Muftic.

TOP Kan Muftic's concept for the now-decrepit environs of Gotham Studios. A grasping Clayface statue can be seen on the central spire.

ABOVE, LEFT A painted moonscape used as a backdrop for a Gotham Studios set. Art by Kan Muftic.

ABOVE, RIGHT A concept by Oliver Odmark for an outer-space movie set.

RIGHT A Lee Oliver concept for an abandoned Old West set inside Gotham Studios.

TOP This busy district of Gotham City was patterned after New York's Times Square. Art by Oliver Odmark.

ABOVE An experiment with creating a fake Gotham City, part of Scarecrow's hallucination. The idea was dropped later on. Art by Kan Muftic.

ABOVE, TOP TO BOTTOM A Kan Muftic illustration of a residential area of Gotham City. Ultimately the team did not use many of these suburban concepts; A group roams in the shadows of Gotham City; An "under the bridge" concept featuring an in-game render with paintover elements by Oliver Odmark.

PREVIOUS SPREAD A still from the promotional teaser for *Arkham Knight*.

TOP A slow-moving airship illuminates the streets below in this concept piece by Kan Muftic.

CENTER AND LEFT Kan Muftic concepts for Gotham City's ubiquitous airships, which play an important role in *Arkham Knight*'s story and gameplay.

OPPOSITE Lee Oliver's study of the various levels in which Gotham City action can occur. Cars, trains, bridges, and balloons all contribute to the vertical feel.

1 Square represents 7 ft 84 inches

252ft

TOP A parade balloon looms much too close in this piece by Oliver Odmark.

LEFT Oliver Odmark studies of various parade balloon designs.

OPPOSITE Poison Ivy commands her plants inside Gotham City's urbanized environment in this piece by Oliver Odmark.

SHOP

①

②

③

④

• SMALL SEED
RISING FAST.

• Hypocotyl and
cotyledon
Breaks through
the ground ←

• Hurling up rubble in
the air as it rises!

Cotyledon

Epicotyl

• New leaves
developing.
• Epicotyl
Straigtens

- New leaves
develop

Hypocotyl

③

NORMAL —

"INHALE" GAS ↓

"INHALE" GAS ↓

— SHIELDED

— DEAD

.A

.B

.C

RIGHT Playing with scale, Oliver Odmark depicts Poison Ivy's plants overtaking a building.

BELOW Batman makes his way across a vine bridge. Art by Oliver Odmark.

OPPOSITE, TOP Oliver Odmark explores flowering buds.

OPPOSITE, BOTTOM Rough sketches by Oliver Odmark showing the contrast between the natural world and the urban one.

○ CHURCH - RUINED. PLANT HAS GROWN IN - AND OUT OF IT

○ MASSIVE LEAVES - CASTING HUGE SHADOWS

○ SMALLER VINES CLIMBING MAIN PLANT - LOOKS LIKE VEINS

Poison Ivy Gas Spores

POISON IVY

STAGE 0 - LONG RANGE MISSILE LAUNCHER. A-D

RED HOOD MECH DRONE - STAGE 2

MILITARY-INDUSTRIAL COMPLEX

THE ARKHAM KNIGHT IS MILITARIZING GOTHAM CITY, **WITH MERCENARIES AND DRONES** THAT ANSWER TO HIS ORDERS.

"The Arkham Knight's forces are setting up checkpoints and watchtowers, planting explosives, and filling Gotham City with military units," says Sefton Hill. "This isn't a case of them just inhabiting the environment; they're changing it—making it unfamiliar and hostile to Batman. The Arkham Knight's plan is to weaponize Gotham City and change the layout of the city in order to destroy the Batman."

Businessman Simon Stagg soon gets in on the action, revealing a Cloudburst device that can disperse Scarecrow's fear gas across all of Gotham City.

Even Harley Quinn is looking to upgrade. In *Arkham Knight*, her ride is a tandem-rotor Chinook helicopter with nostalgic nose art.

The Riddler has acquired a taste for heavy metal, employing robots and eventually climbing inside a gargantuan, weapons-laden mech suit.

Batman's gear is streamlined and improved, but the Dark Knight is David against the Goliaths seeking to rule Gotham City.

PREVIOUS SPREAD A composition of in-game elements used for *Arkham Knight* marketing.

OPPOSITE Lee Oliver designs for a military-grade missile launcher and an autonomous walking drone.

RIGHT The Cloudburst device. Art by Lee Oliver.

FOLD OUT SKI ARM

TELESCOPIC SKI

ABOVE This flying drone study by Lee Oliver depicts how Batman can snag it with his grapnel gun.

RIGHT A heavily armed drone copter. Art by Lee Oliver.

OPPOSITE Two tank designs by Lee Oliver. The lower tank carries a special Cloudburst payload.

RH- Commander Tank - Stage 2

EYE TARGET

WHEN SPOTTED DARTS AT YOU

A

B

C

D

E

F

G

H

THIS PAGE Tank and drone variations. Art by Lee Oliver.

OPPOSITE Lee Oliver studies of a massive burrowing machine.

FOLLOWING SPREAD The Cloudburst device. Art by Lee Oliver.

TRACKS DRIVE THROUGH DRILL MACHINE WITH SPEED

CENTER COCKPIT CAN SLIDE THROUGH AND ROTATE AROUND SO BACK CAN BECOME FRONT

ARM BARRELS SPIN AROUND WORKING WITH SPINING BLADES

R H - TUNNEL EXCAVATOR - STAGE 01

CLOUD BURST DEVICE

Stagg Industries

ABOVE A Lee Oliver concept of the Cloudburst device
mounted inside the nose of an airship.

oResting

oIn use

HARLEY QUINN's RIDE

HARLEY QUINN'S CHINOOK

›3 different bullets in magazines for different take downs for drones

telescopic Barrel

basic front view of barrel and its magazine rotation

revolver style rotation for particular shot

screen opening here

handle rotates around trigger ring

OPPOSITE New tech designs for *Arkham Knight*, produced by Lee Oliver.

ABOVE Kan Muftic concept art depicting Batman's overhead view of the city he has chosen to protect.

BATCLAW

REMOTE ELECTRICAL CHARGE

THIS SPREAD Batman's gear, designed by Lee Oliver and captured here in images produced for *Arkham Knight* marketing.

LINE LAUNCHER

BATARANG

ABOVE The pod used to deliver
Batman's gear is seen in these
concepts by Lee Oliver.

LEFT A view of Batman with his
gear at the ready, produced as a
marketing piece.

OPPOSITE A close-up of Batman's
gauntlet created with in-game
assets.

PROGRAMMING ARKHAM KNIGHT

ON ARKHAM KNIGHT, **PROGRAMMER** **TIM HANAGAN** RAISED THE STAKES.

Everything is active in Gotham City, with a huge number of simultaneous AIs able to participate in riot-scale events.

"*Arkham Knight* is the first time we've implemented a fully dynamic and procedural population in the world of Arkham," says Hanagan. "Our previous games focused on scripted setups to sell the denizens and thugs, which allowed a great deal of detail and polish. This time, we have a much bigger city to fill, and our previous, designer-focused approach was too time-consuming to implement at the required quality level.

"We designed wanderers, riots, and dynamic vehicles to fill the city with life and to get across the idea that Batman really needs to clean up the streets and save his city. Wanderers stroll along, looking for a fight and guarding their territory.

"Riots are groups of thirty to forty thugs, all working together to wreak havoc. Thugs can dynam-

ically form riots all over the city. They will use whatever's at hand to smash, burn, and destroy everything around them. And, in a city full of abandoned vehicles, there are lowlifes just out for a joyride in someone else's car."

The soldiers in the Arkham Knight's militia are a separate, and much more dangerous, threat to the city's security. "These guys really make their presence felt over the course of the night, as their occupation of Gotham City picks up the pace," says Hanagan.

Batman's upgraded look came with its own programming demands. "I was excited to work on a new and badass version of Batman in *Arkham Knight*," says Zafer Coban. "His suit was crafted with the sole purpose to take on a new threat.

OPPOSITE In-game render of *Arkham Knight*'s Harley Quinn.

RIGHT Batman wades into trouble. Art by Kan Muftic.

FOLLOWING SPREAD Oliver Odmark concepts for Gotham City non-combatants and other civilians.

A

B

C

D

E

F

G

H

I

J

K

L

"The way the parts of the armor articulate in the suit was a big animation challenge in itself. Our rigging team did not take this challenge on lightly, and I think that's reflected in the way the suit behaves in-game."

Cloth physics are used to make Batman's cape shift and billow. The cape might be an accessory, but Coban knew it defined the character's iconic silhouette and deserved focused, ongoing attention.

"The cape is such a massive part of Batman's visual identity," he says. "Our approach has always been one of continual improvement, so it's not something we cracked on the first installment. It's something we've engineered and tweaked from game to game, in response to the demands from the new city scales."

In Coban's view, each game in the Arkham trilogy brought the team closer to its ideal version of Batman. "He has become more agile and more nimble," he points out. "His combat is more hard-hitting, and his cape gliding has become more fluid. But we still maintained his human roughness and spirit, and that's the side of him that I think we connect to the most."

For combat systems, Coban's team incorporated the work done for each previous game, and leap-frogged beyond that benchmark for the sequel. *Arkham Knight* benefitted from all the learnings collected to date, as well as the improved hardware of next-generation console systems.

"We added a ton of custom animations for every time you come across an enemy encounter," he says. "The power from the new consoles means more animation allocations, so we really wanted to immerse the player by doing more with those secondary characters. Each moment you come across a thug or civilian, we build purpose and characterization into that individual."

LEFT Concept designs for rioters. Art by Oliver Odmark.

A

B

C

OPPOSITE, TOP Two-Face's thugs, with waste-management uniforms as part of their cover identities. Art by Oliver Odmark.

OPPOSITE, BOTTOM Oliver Odmark concepts for Halloween-inspired gas masks.

THIS PAGE Oliver Odmark concepts for the Arkham Knight's paramilitary mercenaries.

OPPOSITE, LEFT Gotham City Police Department officers.
Art by Oliver Odmark.

OPPOSITE, RIGHT A body-armored Penguin thug. Art by
Oliver Odmark.

ABOVE A thug allied to Harley Quinn. Art by Oliver Odmark.

FOLLOWING SPREAD Batman stretches his wings in this
Arkham Knight marketing image.

THE BATMOBILE

GOTHAM CITY IS SO BIG **THAT BATMAN CAN'T** COMFORTABLY TRAVERSE IT ON FOOT.

" **THE SIZE OF GOTHAM CITY WAS DRIVEN BY THE BATMOBILE, RATHER THAN THE OTHER WAY AROUND.** "

For *Arkham Knight*, the team finally added a long-awaited, player-controlled Batmobile.

"Right from the start of development, the one thing we really wanted to introduce was the Batmobile," says Sefton Hill. "Once we knew we wanted to bring the Batmobile into Gotham City, we started looking at what that meant for the city in terms of size and design. The size of Gotham City was driven by the Batmobile, rather than the other way around."

The inclusion of the vehicle meant determining its role in gameplay, not to mention how much gadgetry it could pack into its armored shell.

"The Batmobile was a major addition," says David Hego. "Its lines are aggressive, and its body's dark silhouette looks strong and impenetrable."

On command, the Batmobile can transform into battle mode. "The weaponry block rises from the main chassis, revealing a range of nonlethal weapons and a more destructive cannon and missile-barrage rack," says Hego. "It becomes a three-hundred-and-sixty-degree destruction machine, capable of firing in one direction while moving in another."

Design influences for the Batmobile included jet fighters, sports cars, and armored tanks.

"The jet fighter can be read in the cockpit, but also in smaller details such as the flaps enhancing the controls while steering, or in the intricate details behind the wheel and the different parts of the chassis," says Hego. "The afterburner's exhaust also calls to mind a high-performance fighter plane.

"The sports car screams through with the Batmobile's brute, raw power, as well as the highly detailed touches on some of the materials such as graphene—an ultra-tough carbon fiber recognizable by its peculiar pattern.

"The tank influence is pretty obvious when driving through the streets of Gotham City: clipping the corners of buildings and fighting head-to-head against an army of armored drones."

Between conceptual drawings and 3-D prototypes, designing the Batmobile took months. "It went back and forth until we managed to fit all the elements in an elegant but realistic manner," says Hego. "Video games let us take artistic license from time to time, but we wanted to make the Batmobile a believable and functional piece of machinery just as much as it was a visually stunning vehicle."

Burnouts, boosts, high-speed ejects, and smashing through building corners are just some of the new actions that the Batmobile introduces into gameplay. When the player is behind the wheel, the Batmobile can feel like an unstoppable force.

"We wanted to create a totally authentic Batmobile experience while still retaining all the detail in the environment," says Hill. "We didn't create a big world just for the sake of creating a big world—it's about creating a fun city for the player to explore—something that's truly authentic to Batman."

PREVIOUS SPREAD A wide view of the Gotham City environment in *Arkham Knight* taken from an in-game perspective.

OPPOSITE Close-up of Batmobile branding taken from an in-game render.

FOLLOWING SPREAD In-game shot of Batman and his new *Arkham Knight* ride.

PREVIOUS SPREAD An X-ray effect of the game's new Batmobile, produced for marketing purposes.

THIS PAGE Additional angles of *Arkham Knight*'s Batmobile, produced by the Sixmorevodka design studio.

PART //5
ARKHAM'S LEGACY

ROCKSTEADY'S APPROACH TO COLLABORATION AMONG CREATIVE PEOPLE **IS ULTIMATELY WHAT'S BEHIND THE SUCCESS OF THE ARKHAM TRILOGY.**

"
WE CONSTANTLY SEARCHED FOR WAYS TO PUSH STORY TO THE PLAYER, RATHER THAN SHOW IT TO THEM.
"

PREVIOUS SPREAD Batman and the Batmobile, as seen in *Arkham Knight*.

OPPOSITE Batman as designed for the marketing of *Arkham City*.

FOLLOWING SPREAD Batman and Gotham City, as seen in *Arkham Knight*.

For fans and critics wowed by the time they've spent in Gotham City, the games have captured the experience of being Batman like nothing before or since.

"From *Arkham Asylum* to *Arkham Knight*, our challenge was to create a cinematic story told through the player's actions," says Paul Crocker. "The player doesn't just watch—he plays the action.

"We constantly searched for ways to push story to the player, rather than show it to them."

Looking back at the story arc of the Arkham trilogy, Rocksteady's Batman saga is both tragic and triumphant.

"When we wrote for Batman, what we were really looking to do was to hit the key story beats of the relationships between the characters," says Sefton Hill. "We weren't trying to write a story that just moved between set pieces—we were trying to write a story that was built on interactions and relationships."

When Rocksteady made its pitch for a Batman game back in 2007, the team structured its approach around four pillars—navigation of the environment, Batman as the world's greatest detective, a smooth and intuitive combat system, and Batman as the invisible predator. After eight years and the record-breaking achievements of *Arkham Asylum*, *Arkham City*, and *Arkham Knight*, those four pillars now support a monument to Super Hero gaming done right.

"The only way we've found to deliver a successful game is hard work, passion, and energy," says Hill. "When you play the games, you should be able to feel that passion in every part of the experience.

"I don't think that's something that you can fake. The love and care is inherent in every moment."

ACKNOWLEDGMENTS

A big thank-you to: Ames Kirshen, Ernest Zamora, Matt Mizutani, Elizabeth Seminario, Craig Mitchell, Lisa Fitzpatrick, Josh Anderson, and the team at Rocksteady.

Editor: Samantha Weiner
Project Manager: Eric Klopfer
Production Manager: True Sims

Library of Congress Control Number: 2014945991

ISBN: 978-1-4197-1385-9

THE ART OF BOOKS SINCE 1949
115 West 18th Street
New York, NY 10011
www.abramsbooks.com